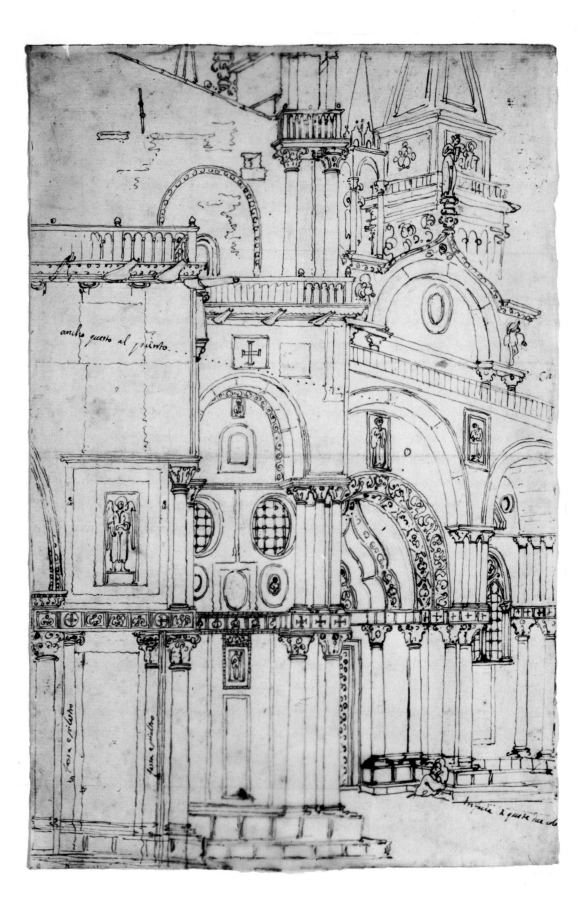

ancho questo al piuisto

la cosa e piastra

cosa e piastra

THE GREAT MASTERS OF DRAWING

DRAWINGS BY
CANALETTO

BY

VITTORIO MOSCHINI

DOVER PUBLICATIONS, INC., NEW YORK

Published in Canada by
GENERAL PUBLISHING COMPANY, LTD.,
30 LESMILL ROAD, DON MILLS, TORONTO, ONTARIO.

Drawings by Canaletto, first published by Dover Publications, Inc., in 1969, is an unabridged and slightly altered republication of the English-language edition of the work first published by Aldo Martello, Milan, 1963, in his series "I Grandi Maestri del Disegno." The present edition, which contains all the original illustrations, is published by special arrangement with Mr. Martello.

International Standard Book Number: 0-486-21990-9
Library of Congress Catalog Card Number: 68-20572

Manufactured in the United States of America

DOVER PUBLICATIONS, INC.
180 VARICK STREET, NEW YORK, N.Y. 10014

FOR ENRICO

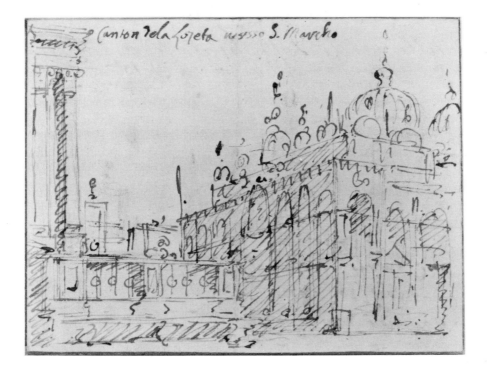

CANALETTO'S DRAWINGS

VENETIAN painting flourished vigorously during the eighteenth century and side by side with it there was a prolific and varied activity in the art of drawing. To mention only the leading artists, Sebastiano and Marco Ricci, Piazzetta, Tiepolo, Canaletto, Longhi and Guardi all expressed essential aspects of their art through the medium of drawing, which became for Piranesi his exclusive aim.

In this case, too, painting, engraving and drawing became practically one form of artistic expression, radiating from the personality of each individual artist. Nevertheless a separate study of one of the three forms is justified because it enables us to establish clear comparisons between works created with the same medium of expression. Such a study, however, is bound to be closely related to the study of the whole, since it becomes particularly important when we try to follow the development of certain works before they reached what can be called their final stage. Preliminary studies, sketches of individual motifs and rough layouts often originated in the form of drawings, and thus acquire a value of their own, especially when they express all the freshness of the original idea. This is true even when, by all sorts of means, they become the forerunners of works carried to a degree of completeness reflecting the artist's vision, and sometimes, to an even greater extent, the taste of the period.

Canaletto, in particular, was a very prolific draughtsman, on an even greater scale than would appear from the drawings which have been preserved. For the latter not only bear numbers justifying the supposition that many others must have existed grouped together in sketchbooks, but they also make it seem probable that among the lost drawings there must have been many

of those rough jottings which Canaletto himself, despite the fact that they earned the approval of a gifted connoisseur like Algarotti, did not think worthy to be shown to the British Consul Smith, or which the latter in any case did not accept.

Although from time to time they reveal different phases of development, the paintings as a whole somehow arrive at the same conclusion, and in fact no preliminary painted studies by Canaletto have been preserved. The drawings, on the other hand, are of numerous kinds, reflecting very different phases in the artist's work. They range from jottings and studies of given objects to sketches containing in synthesis the artist's conception of the whole work, or to drawings more or less finished as regards details and chiaroscuro, which are the equivalent, in black and white, of finished paintings, this being also true of certain drawings by Piazzetta.

Of particular importance in the sphere of rough notes made on the spot is the famous sketchbook now in the gallery of the Accademia at Venice, with its schematic renderings of architectural themes, usually intended to serve as basis for the execution of painted *vedute* such as those acquired by the Duke of Bedford. In reality it is not a matter of great importance whether or not Canaletto used a camera obscura for this purpose, obtaining in this way rough panoramas useful for collating sequences, like the " scaraboto " mentioned by the artist on a drawing in the Viggiano group, or else tracing his lines with the aid of images projected on to the pages of the sketchbook. Even if he did, as is probable, make use of a camera obscura, he certainly did not do this in order to fix the lines automatically on the sheet, for in every case the hand, and not only the hand, of the draughtsman played the chief part in tracing those lines. Contemporary writers mention the use of the camera obscura by Canaletto, and before him by Carlevaris, and we must also remember that in the Museo Correr there is a small portable camera which according to tradition belonged to Canaletto. The use of it is certainly symptomatic of the artist's attitude to the reality of the objects he had to depict, but it does not in any way nullify the value of the results achieved, including those personal solutions of problems which are our particular concern. In fact, in the works by Canaletto which on account of their objective clarity, or the angle of vision, or even more on account of the characteristic reductions of space, justify the supposition that he may have used lenses or a camera obscura, the differences in the results achieved at various stages are so marked that we are bound to ask ourselves whether a living camera obscura such as the eye of the artist, and of such an artist, was not a far more important factor.

In the sketchbook now at the Accademia in Venice we can watch Canaletto at his work, and certain sheets containing rough jottings made on the spot with the crayon should be described as phases of formation rather than as being " without style ". But even in these sketches, certain things are chosen, certain stresses are laid, and what most struck the artist in his observation of reality stands out clearly. A close study of the sheets containing sketches of the Ponte dei Tre Archi, the reproductions of which, even if they are so-called " facsimiles ", are unfortunately poor, reveals that they are not mere transfers to paper of objects seen, but *vedute* which had already taken shape in Canaletto's eye, within a spatial setting, with the masses already outlined and the various elements characterized. That any one sketch and those on the preceding and following pages are to a certain extent " instrumental ", is undoubt-

edly true, since one of the Bedford paintings is obviously based on these sheets, even as regards the details, but that does not in any way impair the independent value of these sketches. This might seem contradictory to those who have not made a close study of the artist's development, but it will perhaps be better to leave it to the philosophers, of whom there is no lack, to find a rational explanation of what is not just a fantasy in the manner of Pirandello. One might say that before proceeding with the execution of the finished drawings and the paintings, another Canaletto intervened, who touched up with his pen most of these rough jottings, endowing them with a rapid and vibrant stylistic character, which in certain wavering and curly lines seems to be almost in advance of his times. But that is not all, for in the same sketchbook, we find drawings free from all preoccupation with minute rendering of reality, which establish various settings and views, often with extreme accuracy. The co-existence in one sketchbook of so many different methods of procedure is a striking demonstration of the system followed by Canaletto in his rendering of things observed. The question would become even more complicated if we were to take into consideration the whole of the master's work as a draughtsman, for this would inevitably lead to uncertainty as to the chronological order, in view of the fact that it has been shown that certain *vedute* in the form of drawings were derived from the paintings.

In the fundamental group of drawings now at Windsor, which Canaletto sold to the Consul Smith and of which at least some must have been specially made for the latter, despite the fact that they do not include documentary notes or rough sketches, we find a remarkable variety as regards character and degree of completeness, and this must be attributed to the various phases of the artist's work during a period of more than thirty years. They range from synthetic renderings full of vigour to others carefully drawn in the manner of engravings and others again with linear outlines and shadows, executed in water-colours. This, however, is not all, for on occasions Canaletto practised making faithful repetitions in the third manner, as if he were using a different instrument, of the same subjects which he had already executed in the second – which gives cause for reflection on the dominant role that stylistic invention must have played in his work.

It may well be that Canaletto's various methods of executing drawings were appreciated in various ways. What has now become the traditional trend of criticism would give its preference to the rough sketches expressing fleeting impressions and ideas by means of a few essential lines. If, however, starting from this way of thinking, which can certainly be justified, we were to go still further and, perhaps only implicitly, were to exclude certain finished drawings simply because they are finished, we would risk arriving at a kind of topsy-turvy academicism, which would make it impossible for us to understand, not only Canaletto's position in the history of art, but even the results he achieved in such drawings. There is no point in comparing lyrical inspiration with carefully meditated execution; what is more important is to be able to discern with ease the point at which, even in the most finished drawings, the poetical urge had an unmistakable rhythm, even if every kind of instrument and device had been used, as is the case in Canaletto's own paintings and engravings.

As everyone knows, Giovanni Antonio Canal called Canaletto (1697-1768) was trained by his father Bernardo to be a painter of theatrical scenery

and until 1720 collaborated with him in the production of settings for several important operas, among them being two composed by Alessandro Scarlatti and performed in Rome during the Carnival of that year. Unfortunately, nothing has been preserved of those " most beautiful designs for scenery " which, according to Zanetti, were made by Canaletto in his early years, nor have we any drawings relating to the two dramatic representations of " Tombs " in memory of Lord Somers and Archbishop Tillotson, for which in 1722 – the correct date as given by Constable – Canaletto and Cimaroli painted views and landscapes, while Piazzetta and Pittoni executed the figures.

Although it cannot be excluded that the transition of Canaletto from the fantasies of scene-painting to the execution of *vedute* based on a strict observation of reality may to a certain extent have been gradual, the fact of his conversion, as clearly stated by Zanetti, is substantially true and retains all its significance. Evidence of Canaletto's new field of activity is provided by a group of works, teeming with pregnant developments, which can be dated approximately from the 1720's, ranging from the large canvases formerly in the Liechtenstein collection to some of the works now in Dresden and Windsor, to the group of *vedute* executed for Stefano Conti, the grandiose paintings of ceremonies and festivals produced for the ambassadors of France and the Austrian Empire, and lastly, the view of the church of Santa Maria della Carità seen from San Vidal. This was certainly a period of intense creative activity, and at this point we can avail ourselves of Haskell's researches and quote the words of the painter Marchesini, who in 1725 wrote of Canaletto that " in this country he is astonishing everyone without exception who sees his works; he continues on the lines of Carlevari, but we see the sun shining " – that Canaletto who painted " not with an imaginative mind in the customary studios of painters... on the contrary he goes to the spot and models everything from reality. "

This period, comprising so many other works which it is not necessary to mention, might obviously be subdivided into several stages, even though for the sake of brevity I have merely grouped the most important canvases together. Side by side with these canvases, full of pictorial freedom and vigorous contrasts of chiaroscuro gradually dissolving into perspectival relief, we have a number of drawings sketched with great rapidity and firmness, with prominent shadows and synthetic abbreviations. To start with, there are certain studies now at Windsor, showing the Piazza San Marco and the Piazzetta, which correspond with the canvases in the same collection as well as the sketch for the view of the Rialto executed in 1725 for Stefano Conti, on the back of which are some figures believed by some critics to be related to studies of Carlevaris, though there is no trace of them in any other drawings. The style of these drawings is definitely individual, so much so that it is not easy to detect derivations. It would seem more likely that the inspiration came from Marco Ricci rather than from Carlevaris, as is the case in the paintings of this period, but everything remains vague, and the same can be said of a certain Rembrandtesque element, which would not be surprising in the Venice of that time. As for that, even in works from Canaletto's later period it is very difficult to discern derivations, and if certain seventeenth-century drawings by Dutch artists such as Beerstraaten, Van der Haagen and more especially Saenredam seem to be an anticipation of Canaletto, this may be nothing more than a case of affinity, which after all is of little importance.

These are followed by other drawings of the same kind, and a point

of reference is provided by the celebrated drawing now in Darmstadt, bearing the date 1729, full of vigorous contrasts and still very impetuous.

Between the end of the 1720's and the first years of the fourth decade Canaletto concentrated more and more on a lucid structure of perspective and dominant lighting. We have no lack of drawings which in one way or another illustrate this new trend, and of particular importance is the return to the theme of the Piazzetta (1732) in the Darmstadt gallery. It corresponds to a *veduta* in the Bedford series, the same painting for which Canaletto utilized most of the drawings in the sketchbook we have mentioned and which can be dated from the first important phase, about 1730 or shortly afterwards if we take into account the back-dating to which a large part of the chronological sequence of Canaletto's works has been subjected during the last few years. The lucid and systematic reproductions in perspective of reality which we find in this sketchbook show what Canaletto's attitude was at that time and how, after having drawn and painted views of Venice for a whole decade, he felt the need of making new studies on the spot.

The fourth decade of the century was one of Canaletto's most prolific periods. His works were much sought after, so much so that Smith, by acting also as intermediary in Canaletto's dealings with English patrons, was able to keep a check on all of them and acquired on his own account whole groups of Venetian *vedute*, which were repeatedly engraved by Antonio Visentini. The connoisseurs were obviously favourably disposed towards Canaletto and showed an unusual appreciation of their value, from MacSwiney, who in 1727 declared that Canaletto was excellent " in painting things that fall immediately under his eye ", and the Swede Tessin, down to De Brosses, who in 1739 described him as the only great painter left in Venice, with a manner which was " claire, gaie, vive, perspective et d'un détail admirable. " And above all he attracted the attention of Zanetti.

Among the works of this decade we need only recall the views in the Bedford series and those formerly in the Harvey collection, the incomparable *Festival of San Rocco* and the *Basin of San Marco* in the museum at Boston (Mass.). But many others could be added which are particularly well balanced and felicitous in their mode of expression. Drawings, too, abounded, as is clearly proved by the stupendous group collected by the Consul Smith and now in the Royal Library at Windsor Castle. The main nucleus of the group dates from this decade and it includes a number of large *vedute* in which perspectival structure stands out amidst the lucidity of the whole, organically delineated by concise and vibrant outlines resembling those of an engraving and above all strikingly " sunny ", while the stresses are already only a little less dazzling than in the stupendous engravings of the following decade. Among these are the views of the Grand Canal at Santa Croce, at the Palazzo Corner, at San Vidal and at Sant'Angelo, filled with animation and light, with silky reflections, like the master's finest paintings, and of the same high quality, although they were probably executed some years later, are several views of Padua, in particular those of the Bastions and of the Brenta near the Portello.

This is not the place to deal with the question of a supposed second stay of Canaletto in Rome about 1740 and of his share in the well-known Roman drawings in the British Museum, now generally recognized as not being by his own hand, despite the comprehensible opposition of certain writers. We must, however, mention, among the sheets now at Windsor, one or two draw-

ings of Roman subjects, vigorously outlined and full of light. They include several of ruins of ancient Rome, as well as that of the Ponte Quattro Capi, and are similar to the drawings of Padua.

About this time Canaletto's nephew Bernardo Bellotto was acting as his assistant, despite the fact that he had become a member of the *Fraglia* of painters on his own account in 1738, when he was only eighteen. He was the only distinguished pupil who remained faithful to Canaletto, and for this reason it is not surprising that there exist paintings and drawings dating from the end of the fourth decade and the first years of the fifth, of which it is still difficult to say whether they are to be attributed to one or the other of the two artists. This is rendered all the more difficult because Bellotto, having thoroughly absorbed all that he could learn from Canaletto, instead of imitating him carried on his work as regards certain trends, achieving results which at times are of equally high quality.

Among the Windsor drawings, particular attention has rightly been dedicated to four large panoramas of unusual clarity as regards linear design and the portions in water-colour. They represent the island of Sant'Elena, a scene on the outskirts of Venice and the city seen from the Motta di Sant'Antonio, and cannot have been executed before the end of the fourth decade. The panorama of Venice, remarkable for the prominence given to a large sailing-ship at its moorings, achieves a dazzling crystalline clarity, while in one of the views of the lagoon off Sant'Elena, with the channels gleaming amidst the shoals and numerous little gondolas and boats gliding over the motionless waters, the use of the ruler, which for pedantic artists was merely a convenient makeshift, becomes a means of achieving great expressiveness.

Although they are not often to be found, there nevertheless exist a few jottings and extremely synthetic rough sketches which one is inclined to attribute to this phase of Canaletto's mature period, even though the exact dates remain uncertain and might be rather later. All the more so because the transition from the fourth to the fifth decade was a gradual one, and it is clear that in a certain sense Canaletto's " English " period began before he went to London in 1746. Among the drawings this is particularly true of the one showing the campanile of St. Mark's after it had been struck by lightning in 1745, with its stylized forms, the undulating little figures, the straight lines and dots on the buildings.

During the first half of the 1740's, Canaletto's creative mind found its clearest expression in the series of etchings, which show how he contrived to dominate and individualize a graphical language which for him, it would seem, was a technical novelty, but to which he was evidently led by his exceptional talents as a draughtsman, the technique similar to that of engraving found in some of his finished *vedute* having served as a kind of starting-point. In making these etchings, he used some of his drawings, with clear outlines as in the *Riverside Village*, with hatched shadows as in the views of Mestre and Dolo, or line and water-colour drawings such as those of the Pra' della Valle at Padua, so intimately rich in their colouring. Of particular interest is the synthetic sketch of the weir at Dolo, both in itself and as a preliminary study for the truly stupendous engraving, the conception of which can already be perceived in the drawing with its constructional relationship between clearly defined zones of light and shadow.

During this period Canaletto tended more and more towards the pictur-

esque, devoting particular attention to *vedute* which were wholly or in part "imaginary", with elements drawn from life placed in different positions or settings, as in the case of the famous tops of gates executed for Smith, or else purely imaginary. This can be seen even in some of the drawings, often containing reminiscences of Venice and Rome, to which English features were later added. Canaletto continued producing works of this kind to the very end.

If we remember that Canaletto's stay in England lasted, with one or two brief interruptions, about ten years, the number of English views may seem to be rather small, especially as regards drawings. It may be, however, that many of these drawings have been lost, especially if they were rough sketches from reality of the type of which only two have survived.

Nevertheless it must be borne in mind that in England Canaletto went on producing, even in the form of drawings, Venetian and Roman *vedute*, as well as others which were purely imaginary, so that the problem of dating them becomes extremely difficult, even when the artist's late manner can be clearly perceived. In many drawings of English scenes Canaletto appears to have used the methods we have already observed in the four Venetian panoramas, for example in the strikingly horizontal proportions, in the meticulous precision of the outlines of every element, whether in the near or far distance. On the other hand we find, especially in the little figures, an accentuation of the sprightly forms already present in certain Venetian drawings of the fifth decade. The most striking and significant example of this is to be found in the view of *Old London Bridge*, which is entirely crystalline, with every tiny detail defined by undulating and sinuous lines, full of little figures whose gestures remind us of ballet-dancers. Here we are far from the synthetic realism of the youthful Canaletto and equally far from the objective contemplation of his middle period; what we have before us is a kind of optical caprice, in which even the visual lucidity is unreal, while on the other hand there is a tendency towards marked stereoscopic effects. This does not invariably occur to the same degree, but in substance the character of the English views remains constant.

Many of these sheets, containing views of the Thames in London, the bridge at Hampton Court, or Warwick Castle, have a subtle charm, undoubtedly related to the richness of the style, and this is not altered by the fact that Canaletto, as was inevitable, saw those scenes to a certain degree with the eyes of a Venetian, endowing them with a certain element of local colour, just as Bellotto did in his views of Dresden and Warsaw. This is a consideration which can also be applied to the paintings, and the negative opinions of some writers must be attributed to Canaletto's tendency towards a stylized manner, which it is too easy to dismiss as a makeshift, since, had he been just lazy, he would have preferred, after 1740, to continue along the lines which had already brought him such success. On the other hand, if we can rid ourselves of our personal preferences for one or the other phase, preferences due to particular and sometimes restrictive trends of taste, the complexity of Canaletto's personality will stand out more clearly even during his late period – a complexity deriving from those contrasts between the objective and the fanciful which had characterized his beginnings.

Just as, during his English period, Canaletto developed certain premisses which had begun to appear shortly after 1740, so, after his return to his own country about 1756, did he continue in his trend towards stylization, with a particular leaning towards the capricious and the grotesque. There are, as is

well known, very few works which reliable data permit us to assign to the late period, but in the case of others the manner alone makes it advisable to assign them to it, though a few chronological errors cannot be excluded. This is particularly true of certain fanciful capriccios, tremulous and undulating, in which Canaletto seems to be aiming at what Guardi later achieved in a very different way.

The most important task to which the master devoted himself during his last phase was the execution of large and meticulous drawings for the twelve etchings of " Ducal Solemnities ", engraved by Giovanni Battista Brustolon and published from 1766 onwards. In these drawings he evinces a still lively interest in architectural and landscape *vedute* placed in clearly defined settings, into which, however, he inserted numerous picturesque figures, and sometimes even a densely packed crowd. These were not personages, let alone portraits, as they sometimes, though only by way of exception, were in works executed many years before, but simply dolls and puppets, or groups of anonymous " extras ", often amusing with their costumes and their quaint gestures. It is not surprising that such compositions should have provided inspiration for Francesco Guardi who, by endowing these types with all the whimsicality and splendour of his delightful art as a painter, produced that famous series of canvases which, for some strange reason, were at one time attributed to Canaletto himself.

For this curiously illustrative series, too, Canaletto made new drawings on the spot, as is proved by the two sheets now in the Fogg Art Museum at Cambridge (Mass.), showing the church of San Nicolò and adjoining buildings. They served as background for the scene showing the Doge's barge at the Lido on the occasion of the ceremony of the " Betrothal with the Sea ", and it is known that several similar drawings existed which have since been lost. Such drawings, revealing the lively interest which the aged Canaletto still took in his work, are very close to the views of Santa Marta used by him for a painting now in Berlin, and their style, determined by the purpose for which they were executed, does not differ from that of the freer and more spirited sketch of the façade of the church of Santa Maria della Pietà. The interior of St. Mark's was also the subject of new studies, and a prospect of the transept of the Basilica must have been used by Canaletto as a basis for the last known drawing by his hand to which a certain date can be assigned, enlivened, like a capriccio, by spirited little figures, especially those of the youthful singers, agitated and fluttering. Proud of his still keen eyesight, he signed the drawing as follows:

Io Zuane Antonio da Canal, Hò fatto il presente disegnio delli Musici che canta nella Chiesa Ducal di S. Marco in Venezia in età de Anni 68 Cenzza Ochiali, Lanno 1766.

(I, Zuane Antonio da Canal, made the present drawing of the musicians singing in the Ducal Church of St. Mark in Venice at the age of 68 years without glasses, the year 1766.)

BIBLIOGRAPHY

N.B. *The following list comprises the most important publications dealing with Canaletto's drawings; some of them, especially those of more recent date, are essential for a thorough understanding of the master's work.*

[A. M. ZANETTI], *Della pittura veneziana*, Venice, 1771; E. A. CICOGNA, *Delle inscrizioni veneziane*, vol. V, Venice, 1842, p. 569 (for the sketchbook now in the Accademia gallery at Venice); H. F. FINBERG, *Canaletto in England*, in " The Walpole Society ", vol. IX, London, 1921, and vol. X, 1922; D. VON HADELN, *Some Drawings by Canaletto*, in " The Burlington Magazine ", December 1926; A. STIX – L. FRÖLICH BUM, *Die Zeichnungen der venezianischen Schule* (in the Albertina), Vienna, 1926; D. VON HADELN, *Die Zeichnungen von Antonio Canal genannt Canaletto*, Vienna, 1930; A. MORGAN – P. J. SACHS, *Critical Catalogue of the Drawings. Fogg Museum of Art*, Cambridge, Mass. (U.S.A.), 1940, second edition 1946; O. BENESCH, *Venetian Drawings of the Eighteenth Century in America*, New York, 1947; K. T. PARKER, *The Drawings of Antonio Canaletto in the collection of His Majesty the King at Windsor Castle*, Oxford and London, 1948; E. ARSLAN, *New Findings on Canaletto*, in " Art Bulletin ", 1948; F. J. B. WATSON, *Canaletto*, London and New York, 1949, second edition 1954 (with bibliography); V. MOSCHINI, *Il libro di schizzi del Canaletto alle Gallerie di Venezia*, in " Arte Veneta ", 1950; F. J. B. WATSON, *Some Unpublished Canaletto Drawings of London*, in " The Burlington Magazine ", November 1950; IDEM, *Eighteenth Century Venice* (catalogue of the exhibition), London, 1951; *Canaletto and English Draughtsmen* (Catalogue of the exhibition), London, 1953; M. MURARO, *Mostra di disegni veneziani del Sei- e Settecento*, Florence, 1953; V. MOSCHINI, *Canaletto*, Milan, 1954 (with bibliography), reviewed by M. CALVESI in " Comunità ", October 1954, and by M. PITTALUGA in " Il Ponte ", July 1955; *Italian Drawings of the Eighteenth Century in the Ashmolean Museum*, Oxford, n.d. [1954]; T. PIGNATTI, *Venetian Seicento and Settecento Drawings: An Uffizi Exhibition*, in " The Burlington Magazine ", 1954; *European Masters of the Eighteenth Century*, London, 1954 (catalogue of the exhibition); G. FIOCCO, *Cento antichi disegni veneziani* (catalogue of the exhibition), Venice, 1955; F. HASKELL, *Stefano Conti, Patron of Canaletto and others*, in " The Burlingon Magazine ", 1956; J. W. GOODISON, *Another Canaletto Drawing of London*, in " The Burlington Magazine ", 1957; W. VITZTHUM, *A Drawing by Canaletto*, in " The Burlington Magazine ", 1957; M. MURARO, *Catalogo della mostra di disegni veneti della collezione James Scholz*, Venice, 1957; T. PIGNATTI, *Il quaderno di disegni del Canaletto alle Gallerie di Venezia*, Milan, 1958 (reviewed by R. PALLUCCHINI in " Arte Veneta ", 1958, and by GÜNTER ARNOLDS in " Zeitschrift für Kunstgeschichte ", 1959, part I); K. T. PARKER, *Disegni veneti di Oxford* (catalogue of the exhibition), Venice, 1958; *Canaletto in England* (catalogue of the exhibition), London, 1959; C. L. RAGGHIANTI, *Procedimento di Canaletto*, in " Sele-arte ", July-August, 1959; D. GIOSEFFI, *Canaletto – Il quaderno delle Gallerie veneziane e l'impiego della camera ottica*, Trieste, 1959 (reviewed by B. A. R. CARTER in " The Burlington Magazine ", 1962; A. MORASSI, *Disegni veneti del Settecento nella collezione Paul Wallraf* (catalogue of the exhibition), Venice, 1959; W. R. REARICK, *Italian Eighteenth Century Drawings at Wellesley College*, in " Arte Veneta ", 1959-1960; R. PALLUCCHINI, *La pittura veneziana del Settecento*, Venice-Rome, 1960; C. BRANDI, *Canaletto*, Milan, 1960; *Italian Art and Britain* (catalogue of the exhibition), London, 1960; E. SAFARÍK, *Canaletto view of London*, London, 1961; O. BENESCH, *Disegni veneti dell'Albertina di Vienna* (catalogue of the exhibition), Venice, 1961; R. OERTEL, in " Kunstchronik ", June 1961 (review of the above-mentioned books by T. PIGNATTI and D. GIOSEFFI); T. PIGNATTI, *Il Settecento*, in *Pittura in Europa*, vol. IV, Milan, 1961; W. G. CONSTABLE, *Canaletto*, Oxford, 1962 (with bibliography and catalogue); [F. WATSON], *The Painter of Venice* (review of Constable's book), in " The Times Literary Supplement ", 2 Febrary 1962; M. LEVEY, *Canaletto* (review of the same book), in " The Burlington Magazine ", 1962; F. HASKELL, in " The Art Bulletin ", 1962 (review of Constable's book); V. MOSCHINI, in " Arte Veneta ", 1962 (review of Constable's book); *Le dessin italien dans les Collections Hollandaises* (catalogue of the exhibition), Paris, 1962; M. LEVEY, *Canaletto's Fourteen Paintings and Prospectus Magni Canali*, in " The Burlington Magazine ", 1962; K. T. PARKER and J. BYAM SHAW, *Canaletto e Guardi* (catalogue of the exhibition of drawings), Venice, 1962.

Illustrations Nos. 7, 23, 24, 25, 26, 30, 32, 34, 35, 36, 37, 38, 43, 44, 47, 48, 55 and 57 have been reproduced by gracious permission of Her Majesty Queen Elizabeth; No. 46 by permission of the Cabinet of Engravings, Ehemalige Staatliche Museen, Berlin; No. 62 by permission of the Fogg Art Museum, Harvard University, Cambridge (Mass.).

1. The Piazzetta, between the Ducal Palace and the column of St. Mark. The campanile of San Giorgio in the background still has the pointed top which was altered during the reconstruction between 1726 and 1728, and this, together with the free and rapid execution, confirms that the drawing belongs to Canaletto's youthful phase. It is closely akin to another drawing now at Windsor, which was perhaps, judging by certain more finished details, made later. Both drawings are connected with a painting in the Royal Collection. – Oxford, Ashmolean Museum, pen drawing (8 7/8 × 7 inches; 225 × 176 mm.).

2. The Piazzetta, seen from the Mole, between the column of St. Theodore and the Marciana Library. One of the most interesting of the few drawings dating from the artist's early period, broadly conceived with vigorous contrasts. Related to one of the paintings in the Royal Collection. – Windsor Castle, Royal Library, pen drawing with crayon outlines (9 1/4 × 7 inches; 234 × 180 mm.).

3. Between the front of St. Mark's and the Campanile, with the Procuratie Vecchie in the background. In the same manner as the preceding drawing and likewise related to one of the paintings in the Royal Collection. – Windsor Castle, Royal Library, pen drawing with crayon outlines (8 3/8 × 7 1/2 inches; 223 × 188 mm.).

4. The Rialto bridge with the Palazzo dei Camerlenghi and the vegetable market on the right and the Fondaco dei Tedeschi on the left. This drawing, which is a striking example of a quick rendering of reality, served as basis for one of the paintings executed for Stefano Conti in 1725. The distribution of light is identical, and the word *Sole* (= sun) corresponds to the most luminous portion of the Canal in the painting. – Oxford, Ashmolean Museum, pen drawing with red and black crayon outlines (5 1/2 × 8 inches; 140 × 202 mm.).

5. Piazza San Marco, looking towards the Basilica. A stupendous drawing, still in the youthful manner. Related to one of the paintings in the Royal Collection. – Windsor Castle, Royal Library, pen drawing (7 × 9 1/4 inches; 180 × 234 mm.).

6. The Mole, showing the Bucintoro (Doge's barge). A rapid sketch, probably made for one of the " Sensa " festivals. Although it does not exactly correspond with any of them, the drawing is reminiscent of several pictures, in particular that painted for the Comte de Gergy, Ambassador of France in Venice, who arrived in the city in 1726. – Windsor Castle, Royal Library, pen drawing with crayon outlines (8 1/4 × 12 1/8 inches; 211 × 318 mm.).

7. The Mole, looking towards the Riva degli Schiavoni. This vigorous drawing still shows marked contrasts in the chiaroscuro. In style and in the layout of the view, it is very close to the well-known sheet dated 1729 in the Cabinet of Drawings at Darmstadt. – Windsor Castle, Royal Library, pen drawing with crayon outlines (7 × 12 1/8 inches; 195 × 308 mm.).

8. The Dogana and Santa Maria della Salute, seen from the Mole. This free and concise sketch made on the spot is still in the manner of the youthful period. The alleged connexion with a painting at Windsor Castle is a very slender one. – Oxford, Ashmolean Museum, pen drawing with crayon outlines (5 3/4 × 8 7/8 inches; 147 × 225 mm.).

9. A boat laden with barrels. Although the theme is not uncommonly found in Venice, we should note the affinity, to which Pignatti drew attention, with one of the large paintings of the youthful period formerly in the Liechtenstein collection, the date of which, however, is not certain and may vary by several years. In any case it is one of the earliest items in the famous sketchbook which Cicogna, who

vouched for its authenticity, saw in 1842 in the house of his friend Giuseppe Pasquali and which Don Guido Cagnola, acting on the advice of Fernanda Wittgens, presented to the Venetian Accademia Gallery in 1949. – Venice, Accademia, black crayon (9 × 6 3/4 inches; 228 × 170 mm.).

10-11. The Grand Canal from Palazzo Corner della Regina to Ca' Pesaro. These jottings made on the spot, which reveal the close attention paid by the artist to architectural forms, were used, as Constable has pointed out, for one of the paintings in the Bedford series. – Venice, Accademia, black crayon (each, 9 × 6 3/4 inches; 228 × 170 mm.).

12-13 The Ponte dei Tre Archi. One of the most striking examples of a crayon drawing executed rapidly without any retouching. These two sheets, together with others showing the banks of the Cannaregio and San Giobbe, were faithfully reproduced in one of the Bedford paintings. – Venice. Accademia, black crayon (each 9 × 6 3/4 inches; 228 × 170 mm.).

14. Piazza San Marco and the Piazzetta seen from the arcades of the Procuratie Vecchie. A synthesis reduced to essentials, which, in view of the luminosity of the shadows, can perhaps be dated about 1730. – Venice, Accademia, pen drawing (9 × 6 3/4 inches; 228 × 170 mm.).

15-16. The Grand Canal from Palazzo Bernardo to Palazzo Papadopoli. These sheets form part of a group which must have been used for one of the Bedford paintings and for a drawing in Windsor Castle. Interesting, on account of its freedom of execution, is the double rendering of the Palazzo Bernardo. The geometrical conciseness of certain details is found again in other drawings of much later date. – Venice, Accademia, pen drawing with black crayon outlines (each 9 × 6 3/4 inches; 228 × 170 mm.).

17-18. The gateway of the Arsenal. In the first drawing, the houses on the Rio, seen at an angle. Together with two other sheets, were used for a drawing at Windsor Castle and for one of the Bedford paintings. – Venice, Accademia, red crayon and pen (each, 9 × 6 3/4 inches; 228 × 170 mm.).

19-20. The Grand Canal near Sant'Angelo. Note the Palazzo Corner Spinelli and certain buildings which no longer exist, for example the Sant'Angelo theatre. These sheets form part of a group which must have been used, as Constable has observed, for a painting belonging to the Earl of Normanton. – Venice, Accademia, black crayon and pen (each, 9 × 6 3/4 inches; 228 × 170 mm.).

21. Façade of the Scuola di San Marco (upper portion on the left). – Private collection, pen drawing (7 1/4 × 8 1/8 inches; 185 × 207 mm.).

22. Façade of the Scuola di San Marco (upper portion on the right). According to Constable, this and the preceding sheet, as well as fourteen others purchased as a group by Italico Brass in 1935 and probably once in the Algarotti collection, formerly belonged to one sketchbook, a theory which is not very convincing on account of the differences between them and also because they belong to various periods, as Constable himself admits when he dates them about 1745-46 with certain exceptions. It is more likely that they are separate sheets, even if some of them can be grouped together, as is the case with the Viggiano group, which likewise came from the Algarotti collection. This and the preceding sketch of the Scuola di San Marco, so succinct, so vibrant and free from all formalism, cannot be dated later than the middle of the fourth decade of the century. – Private collection, pen drawing (6 3/4 × 8 1/4 inches; 172 × 210 mm.).

23. The Grand Canal at the junction with the Cannaregio. According to one writer, the date 16 July 1734 is written on the back, now covered over. However this may be, the dating is more or less in agreement with the style of the drawing. Except for the boats, it corresponds with a painting of the first series engraved by Visentini, published in 1735. – Windsor Castle, Royal Library, pen drawing with crayon outlines (7 3/8 × 10 5/8 inches; 187 × 270 mm.).

24. Piazza San Marco and the Procuratie Nuove, seen from the Piazzetta dei Leoncini. The museum at Rotterdam contains a copy identified as being by Bellotto. Later on, Canaletto produced

another development of this view in one of his engravings. – Windsor Castle, Royal Library, pen drawing with crayon outlines (7 1/2 × 10 3/4 inches; 190 × 274 mm.).

25. The basin of St. Mark's and the Riva degli Schiavoni, seen from San Biagio. The subject and style are reminiscent of several other drawn or painted views, in particular of the painting now in the museum at Vienna. – Windsor Castle, Royal Library, pen drawing with crayon outlines (8 1/8 × 14 3/4 inches; 205 × 376 mm.).

26. The Grand Canal from the Palazzo Contarini dagli Scrigni to Ca' Rezzonico. On the right is the " riva " near San Vidal, where the marble workshop of the famous picture in the National Gallery, London, was situated. For this drawing and a corresponding painting in the Bedford series Canaletto must have used several sketches in the album now at the Accademia in Venice. – Windsor Castle, Royal Library, pen drawing with crayon outlines (8 3/4 × 14 3/4 inches; 220 × 376 mm.).

27. The Grand Canal near Santa Croce, looking towards San Geremia. For this drawing, as well as for the Bedford and Harvey paintings, in which the *burchiello* (= wherry) also figures, Canaletto must have made use of the sketchbook now in the Accademia at Venice. – Windsor Castle, Royal Library, pen drawing with· crayon outlines (10 5/8 × 14 7/8 inches; 270 × 377 mm.).

28. The Grand Canal near Sant'Angelo, looking towards Rialto. Like the preceding drawings, this is a finished work equivalent to an engraving. It corresponds with a painting of the Bedford group and with several drawings in the above-mentioned sketchbook. – Windsor Castle, Royal Library, pen drawing with crayon outlines (10 5/8 × 14 7/8 inches; 270 × 377 mm.).

29. Panorama of Venice from the Motta di Sant'Antonio. – Windsor Castle, Royal Library, pen and water-colour with crayon outlines (6 1/8 × 13 5/8 inches; 156 × 346 mm.).

30. The islands of Sant'Elena and San Pietro di Castello. Together with the preced-

ing and two other similar drawings forms part of an isolated group of delightful panoramas which can be dated about the end of the 1730's. – Windsor Castle, Royal Library, pen and water-colour with crayon outlines (6 1/8 × 13 3/4 inches; 155 × 352 mm.).

31. Venetian buildings. More likely to be convents than dwelling-houses. Forms part of the Viggiano group. – Private collection, pen drawing (4 3/4 × 6 3/4 inches; 121 × 172 mm.).

32. Exterior of a villa, with two statues. – Windsor Castle, Royal Library, pen drawing with crayon outlines (5 3/8 × 7 3/4 inches; 136 × 197 mm.).

33. View of Padua, showing the church of San Francesco. Jottings made on the spot, probably used for the finished drawing reproduced below. One of the Viggiano group. – Private collection, pen drawing (3 3/8 × 5 1/4 inches; 86 × 135 mm.).

34. Statues in front of a villa. – Windsor Castle, Royal Library, pen drawing with crayon outlines (5 1/4 × 7 3/4 inches; 137 × 197 mm.).

35. View of Padua from the Bastions. Note the Porta Pontecorvo and, further back, the basilica of Santa Giustina. – Windsor Castle, Royal Library, pen drawing with crayon outlines (7 1/2 × 10 3/4 inches; 189 × 272 mm.).

36. View of Padua from the Bastions. – Windsor Castle, Royal Library, pen drawing with crayon outlines (10 3/4 × 14 7/8 inches; 272 × 378 mm.).

37. Ruins of the temple of Venus and Roma, with the church of Santa Francesca Romana and the Arch of Titus. – Windsor Castle, Royal Library, pen drawing (7 1/2 × 10 5/8 inches; 189 × 271 mm.).

38. View of the Tiber from the Ponte Quattro Capi (detail). – Windsor Castle, Royal Library, pen drawing with crayon outlines (the complete drawing, 10 5/8 × 14 3/4 inches; 270 × 375 mm.).

39. View of Rome. Corresponds to the group of buildings in the background of the " Coliseum " now at Hampton Court, buildings which, as Constable pointed

out when discussing the painting, exist only in part on the spot, being combined with elements of the churches of San Gregorio and Santi Giovanni e Paolo. On the right we see a rough version of the Arch of Constantine. It is not clear whether this is a preparatory sketch (for what work?), or a drawing by Canaletto's own hand derived from the painting, the date of which (1743) is a point of reference. Even Constable fails to identify it; others suggest that it represents buildings in Vicenza. Part of the Viggiano group. – Private collection, pen drawing (10 × 6 inches; 103 × 153 mm.).

40. Arches. This concisely constructed architectural composition is probably a *capriccio*. Forms part of the Viggiano group. – Padua, Fiocco collection, pen drawing (3 1/4 × 6 inches; 84 × 152 mm.).

41. Imaginary view. A stupendous *capriccio*, which must date from the period of the engravings. One of the Viggiano group. – Private collection, pen drawing with crayon outlines (4 × 5 5/8 inches; 102 × 144 mm.).

42. Imaginary view with the approach to a bridge. One of the Viggiano group, like another very similar sheet published by Constable. – Private collection, pen drawing (3 1/4 × 6 3/8 inches; 82 × 162 mm.).

43. Santa Giustina in the Pra' della Valle at Padua (detail). Preparatory sketch for the corresponding engraving which was probably executed about 1742. – Windsor Castle, Royal Library, pen and water-colour with crayon outlines (complete drawing, 10 5/8 × 14 3/4 inches: 271 × 375 mm.).

44. The Pra' della Valle at Padua with the church of the Misericordia (detail). Preparatory drawing for the engraving executed at the same time as the preceding. – Windsor Castle, Royal Library, pen and water-colour with crayon outlines (complete drawing, 10 3/4 × 14 3/4 inches; 273 × 375 mm.).

45. Figures in a market-place. The well-head is the one still to be seen in the Piazzetta dei Leoncini at Venice, in front of the former church of San Basso. Rough sketches on the verso of a sheet (repro-duced as the frontispiece in this volume) showing the north aspect of St. Mark's looking towards San Basso, and agreeing with two sheets in the museum of Berlin, one of which is reproduced below as No. 46; it is probable that these two sheets together with many others formed a set of sketches, a theory which is supported by the numbers they bear. The Berlin sheet showing the houses towards San Basso, bearing the number 59, formed a pair with the other drawing of the Campo San Basso published by Constable and bearing the number 58. These sheets obviously belong to a late period, but it is not possible to establish an exact dating. – Rotterdam, Boymans-Van Beuningen Museum, pen drawing (17 1/2 × 11 5/8 inches; 445 × 295 mm.).

46. Rowers and other figures. Probably studies of rowers and spectators made during a regatta. – Berlin, Cabinet of Engravings, pen drawing with crayon outlines (10 3/4 × 15 3/4 inches; 272 × 401 mm.).

47. The Piazzetta with the Campanile of St. Mark's under repair (detail). Made shortly after the Campanile had been struck by lightning on 23 April 1745. Representative of Canaletto's taste when he was already tending towards the stylized forms of his English period, which began about a year later. – Windsor Castle, Royal Library, pen and water-colour (complete drawing, 16 3/4 × 11 1/2 inches; 425 × 292 mm.).

48. The Thames, with Westminster Bridge during a water festival (detail). This drawing can be dated about 1746-47. Note the elaborate calligraphy of the little figures and the stereoscopic relief of the buildings. – Windsor Castle, Royal Library, pen and water-colour with crayon outlines (complete drawing, 11 1/4 × 19 1/8 inches; 274 × 486 mm.).

49. View of London, showing the Thames at Westminster Bridge during a public festival. To be dated not earlier than 1747. – London, British Museum, pen and water-colour (12 × 20 1/4 inches; 306 × 513 mm.).

50. View of St. James's Park. In the centre background the old Horse Guards, demolished in 1749-50. The drawing, which

is related to paintings of the same subject, thus belongs to the early part of Canaletto's stay in England. – London, British Museum, pen and water-colour (13 5/8 × 27 1/8 inches; 346 × 688 mm.).

51. Little Walsingham House, London. A sketch of trees and buildings near St. James's Park, with a very modern touch. Forms a pair with the following drawing and both belong to the Viggiano group. – Private collection, pen drawing (5 1/4 × 7 1/2 inches; 134 × 189 mm.).

52. The old Horse Guards and the Banqueting Hall. Like No. 50, this drawing must have been made before the autumn of 1749, when the old Horse Guards building was demolished and a new one built. Together with the preceding sketch it was used, as Watson has pointed out, for a painting formerly in the Wilmot collection. – Private collection, pen drawing with crayon outlines (4 1/2 × 8 1/8 inches; 114 × 217 mm.).

53. View of the square at Warwick, with, St. Mary's Church in the background. – London, British Museum, pen and water-colour (14 × 11 inches; 354 × 282 mm.).

54. View of London through an arch of Westminster Bridge. – Windsor Castle, Royal Library, pen and water-colour with crayon outlines (11 3/4 × 19 1/8 inches; 298 × 484 mm.).

55. Detail of the preceding drawing.

56. The Thames from the terrace of Somerset House, looking towards St. Paul's Cathedral. – Windsor Castle, Royal Library, pen and water-colour with crayon outlines (7 7/8 × 19 inches; 200 × 485 mm.).

57. The Thames from the terrace of Somerset House, looking towards Westminster (detail). The date of this and the preceding drawing must be about 1750. – Windsor Castle, Royal Library, pen and water-colour with crayon outlines (complete drawing, 8 1/2 × 18 3/4 inches; 215 × 475 mm.).

58. Capriccio, showing Montagu House. A picturesque medley, of which other versions exist, combining a view of the old Montagu House in London with elements from the Venetian lagoon. – London, Victoria & Albert Museum, pen and water-colour (9 3/8 × 15 1/8 inches; 238 × 383 mm.).

59. Capriccio, with a mill. – London, Victoria & Albert Museum, pen and water-colour (10 × 16 inches; 253 × 406 mm.).

60. Capriccio, showing ruins and a bridge. One of the freest fantasies in the Rococo vein, dating from the artist's late period. – London, British Museum, pen and water-colour with crayon outlines (9 3/8 × 15 1/8 inches; 238 × 385 mm.).

61. Capriccio, showing a *squero* (= boat-builder's yard). Against a picturesque background of ruins, we see on the right a wooden cradle on which a boat is being built. Although the dating of this stupendous drawing is uncertain, there are reasons for assigning it to the late period. – Private collection, pen drawing with crayon outlines (7 1/4 × 10 7/8 inches; 183 × 276 mm.).

62. Capriccio, showing a round church on the shores of a lagoon. On account of the typical curly calligraphy, this drawing must be assigned to Canaletto's last phase; it was partially used by Guardi in a drawing now in the Correr Museum, Venice. – Cambridge (Mass.). Fogg Art Museum, pen and water-colour (7 3/4 × 13) inches; 197 × 330 mm.).

63. A theatrical performance in Piazza San Marco. A vivacious drawing, which Constable rightly considers should be dated after Canaletto's stay in England. Note how it still has traces of the stylized calligraphy which Canaletto began to adopt about 1745. – London, Victoria & Albert Museum, pen and water-colour (8 × 12 inches; 204 × 313 mm.).

64. The Giudecca canal, showing the bridge of boats for the festival of the Redentore. This and the following drawing are among the most brilliant sketches in the Viggiano group. – Private collection, pen drawing (3 1/4 × 6 inches; 84 × 152 mm.).

65. A church and a square with a statue. In the church Constable has rightly drawn attention to elements reminiscent of St. Paul's Cathedral, London. This would confirm its assignation to the late pe-

riod. – Private collection, pen drawing (4 1/4 × 7 1/2 inches; 108 × 191 mm.).

66. Façade of the church of La Pietà in Venice. The building of this church was begun in 1745 and it was consecrated in 1760, but the facade remained unfinished, as seen in the drawing, until 1903. The sketch must therefore belong to Canaletto's last period. – Janos Scholz collection, pen drawing with crayon outlines (6 × 4 3/8 inches; 152 × 120 mm.).

67. The Doge visiting the church of San Zaccaria on the afternoon of Easter Sunday. This and the following drawing belong to the series of *Solennità Dogali* drawn by Canaletto and engraved about 1766 by Giovanni Battista Brustolon. – London, British Museum, pen and watercolour (15 1/4 × 21 5/8 inches; 387 × 550 mm.).

68. Festival in the Piazzetta on the last Thursday in Carnival, in the presence of the Doge. – Collection of the Earl of Rosebery, pen and water-colour (15 × 21 3/4 inches; 381 × 553 mm.).

69. The church of Santa Marta in Venice. A study made on the spot for the well-known painting of the Festival of St. Martha now in the Gymnasium zum Grauen Kloster, Berlin. Of uncertain date, but in the style of the late period. –

Private collection, pen drawing (7 × 11 1/8 inches; 117 × 283 mm.).

70. Houses near the church of Santa Marta in Venice. Companion piece to the preceding drawing and was used for the same painting. – Private collection, pen drawing (7 × 11 1/8 inches; 180 × 283 mm.).

71. Interior of the Basilica of St. Mark's. A detailed drawing, without figures, of the transept of St. Mark's executed after rough sketches and used in its turn for the following drawing. – London, Victoria & Albert Museum, pen drawing with red and black crayon outlines (15 3/8 × 12 1/2 inches; 391 × 317 mm.).

72. Interior of St. Mark's. This is a carefully finished drawing, in which Canaletto took a special delight in depicting " the singing musicians ", as we learn from the inscription he placed on it together with his signature and the date 1766, two years before his death after a long illness. – Hamburg, Kunsthalle, pen and water-colour (14 1/8 × 10 7/8 inches; 359 × 275 mm.).

In the text (p. 7): The Basilica of St. Mark's, seen from the Loggetta. – Oxford, Ashmolean Museum, pen drawing (3 1/2 × 4 3/4 inches; 89 × 122 mm.). As the frontispiece, recto of the sheet reproduced as No. 45.

PLATES

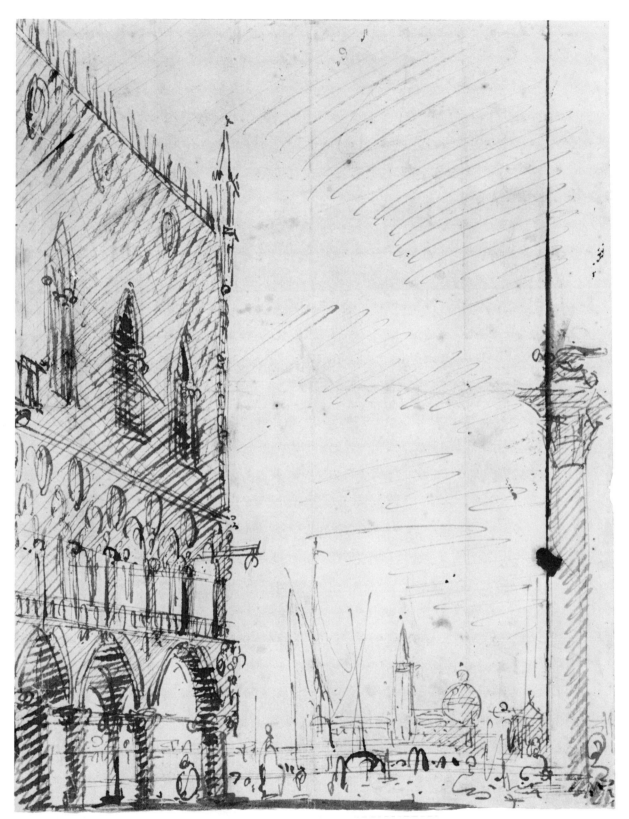

1 *The Piazzetta, Venice*

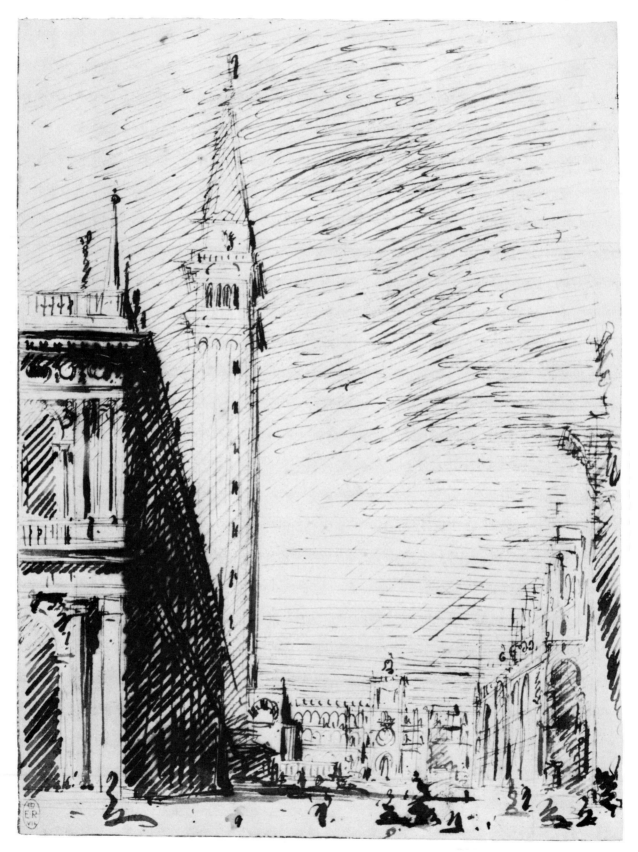

2 *The Piazzetta, seen from the Mole*

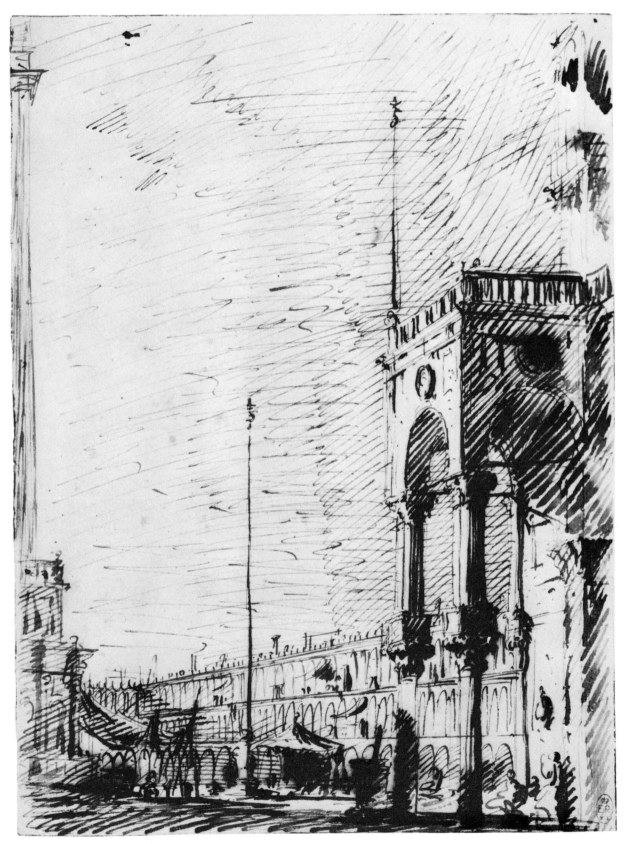

3 *View between St. Mark's and the Campanile*

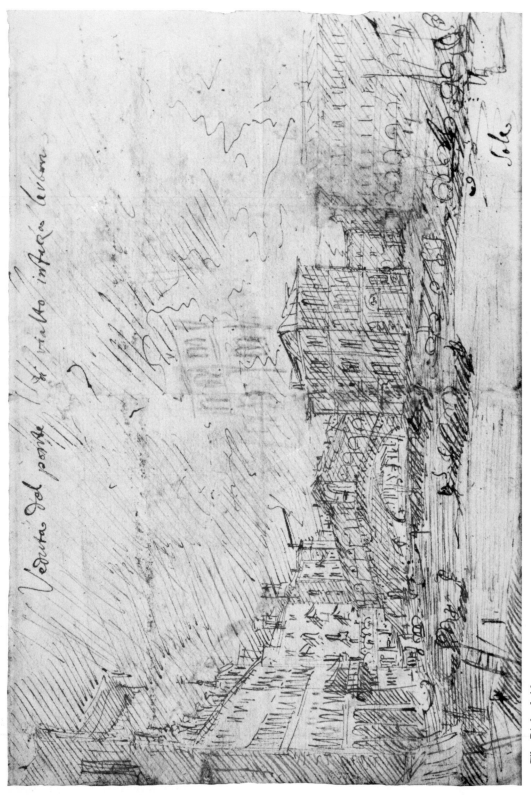

4 *The Rialto bridge*

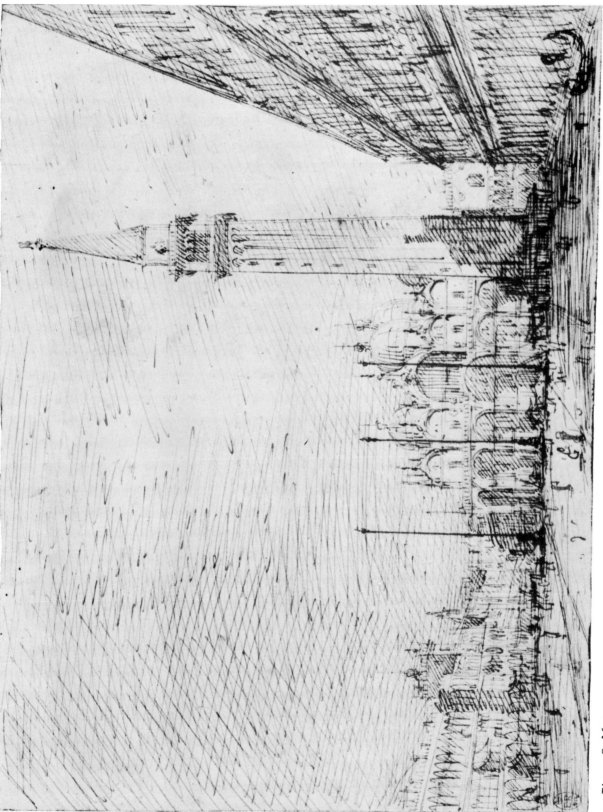

5 *Piazza S. Marco*

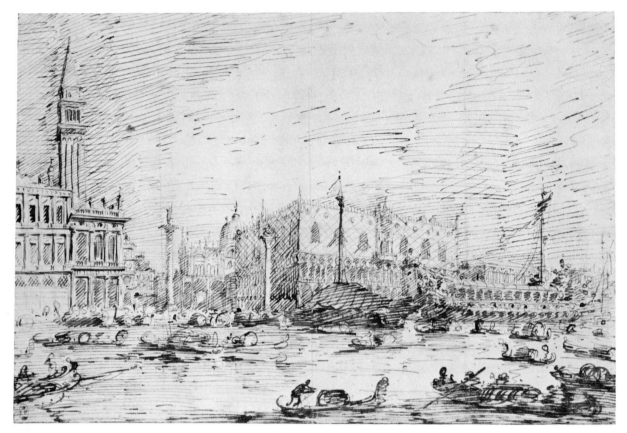

6 *The Mole, with the Bucintoro*

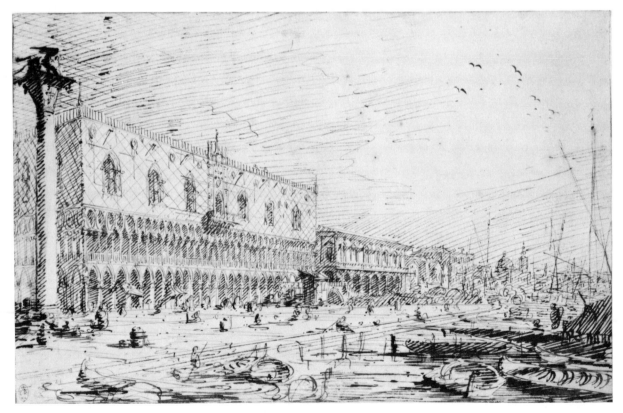

7 *The Mole, looking towards the Riva degli Schiavoni*

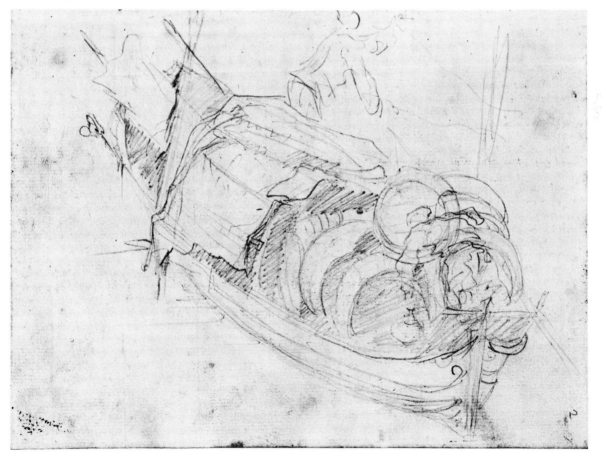

8 *The Dogana and S. Maria della Salute*

9 *Boat laden with barrels*

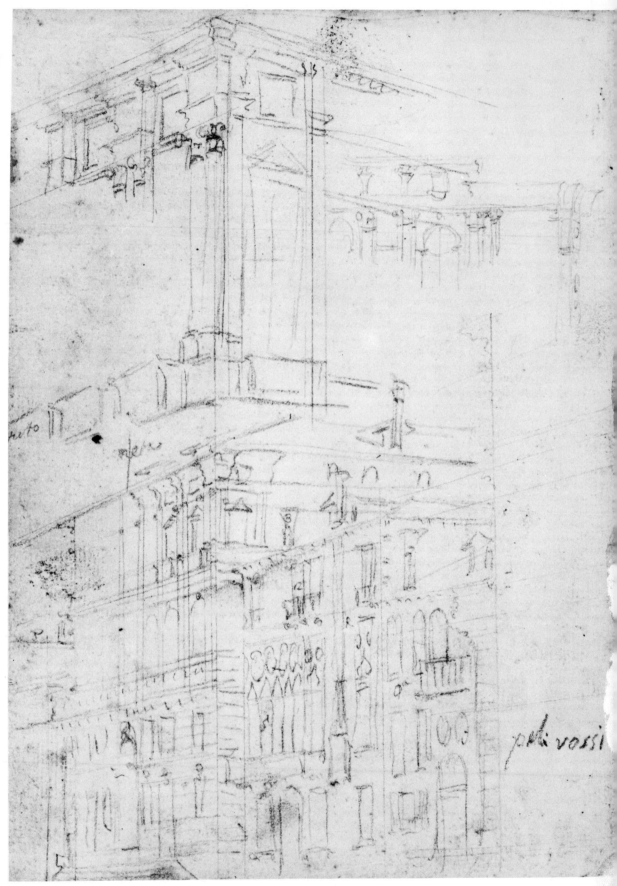

10 *The Grand Canal from Palazzo Corner della Regina to Ca' Pesaro*

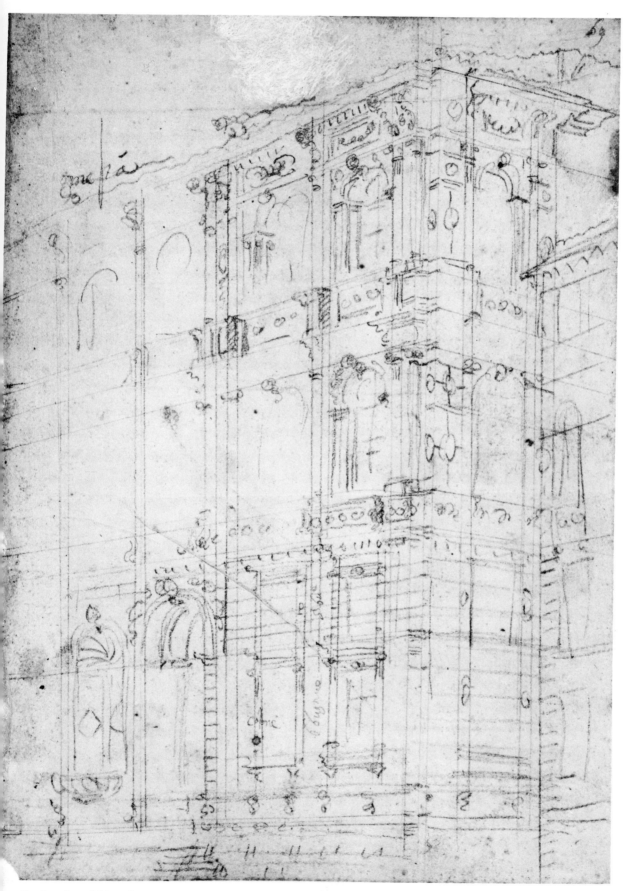

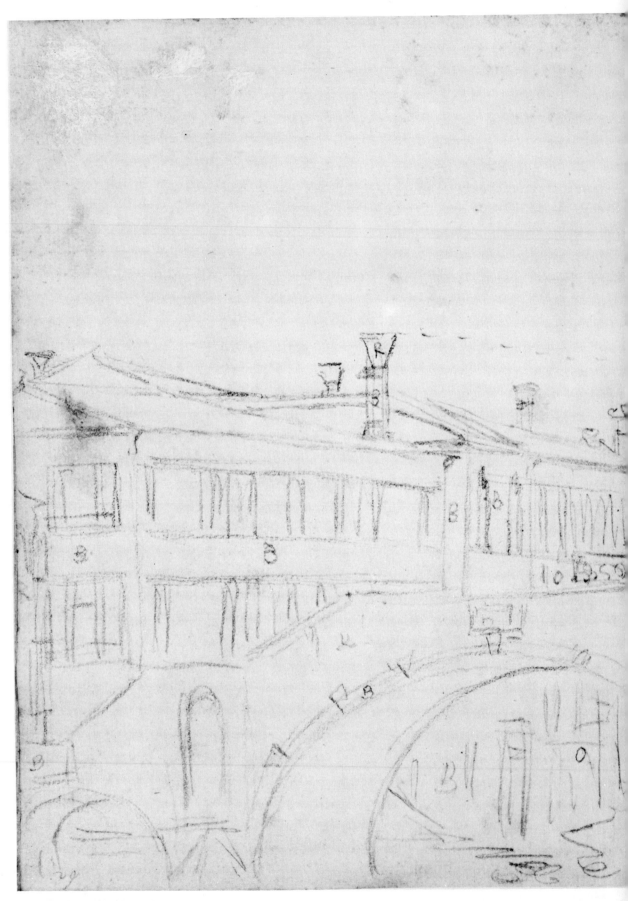

12 *The Ponte dei Tre Archi*

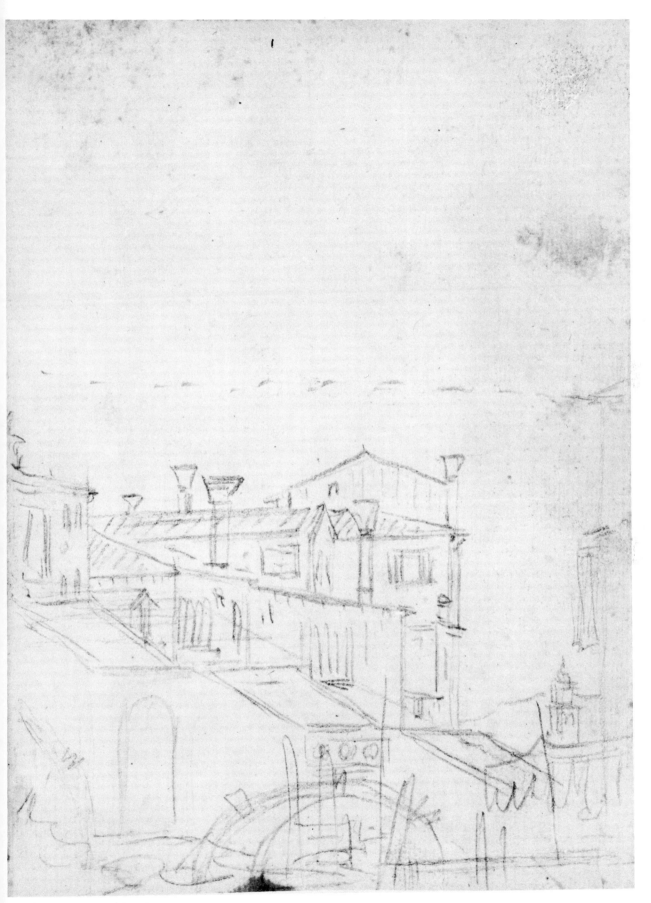

13 (*Continuation of No. 12*)

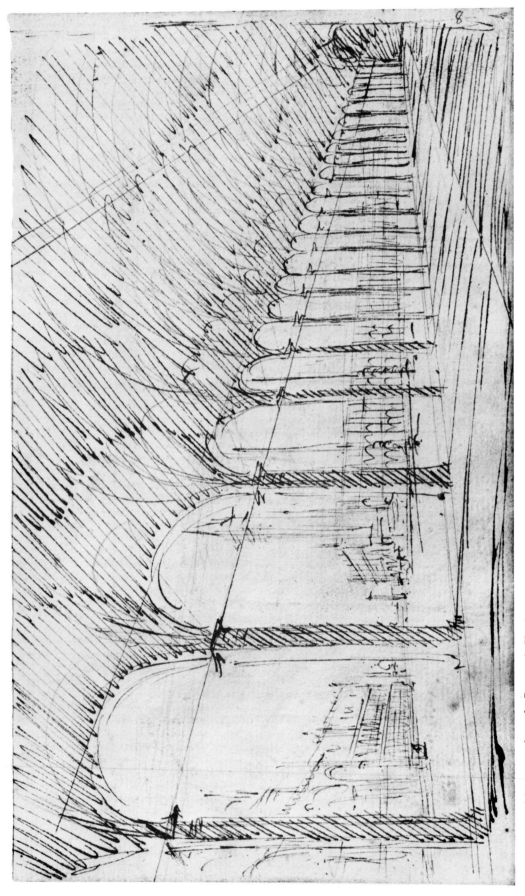

14 *Piazza S. Marco seen from the Procuratie Vecchie*

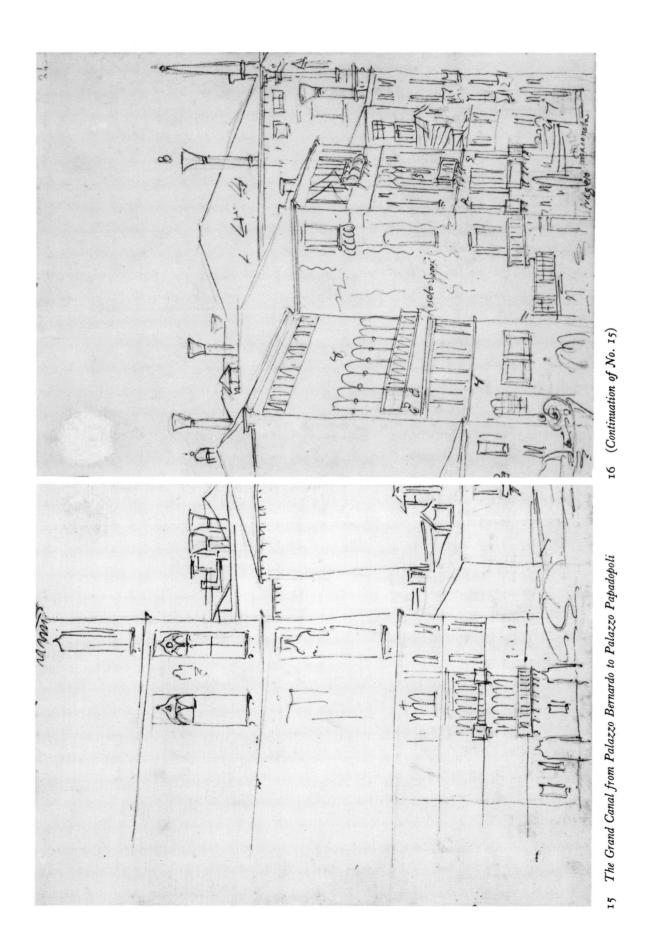

15 *The Grand Canal from Palazzo Bernardo to Palazzo Papadopoli*

16 *(Continuation of No. 15)*

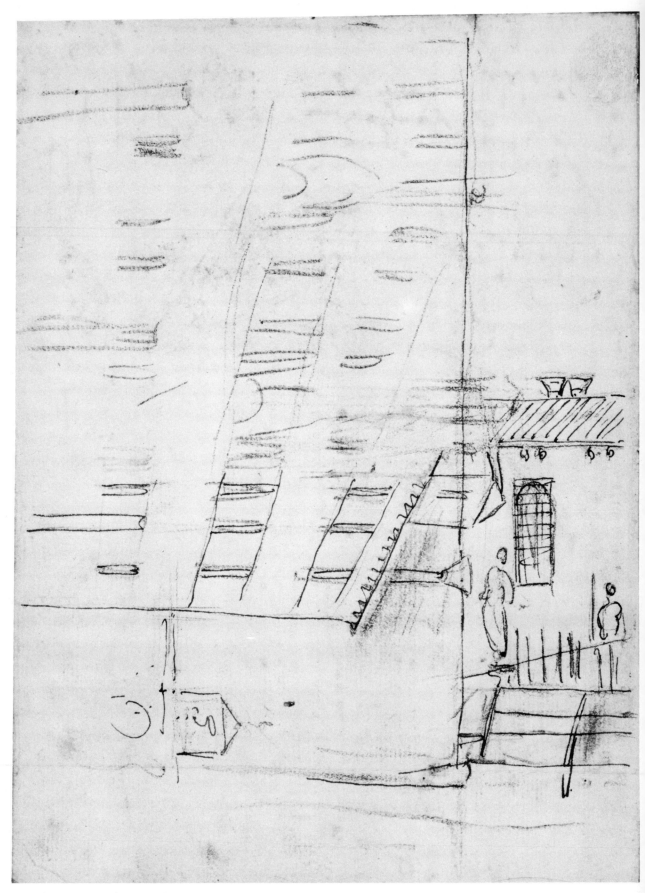

17 *The gateway of the Arsenal*

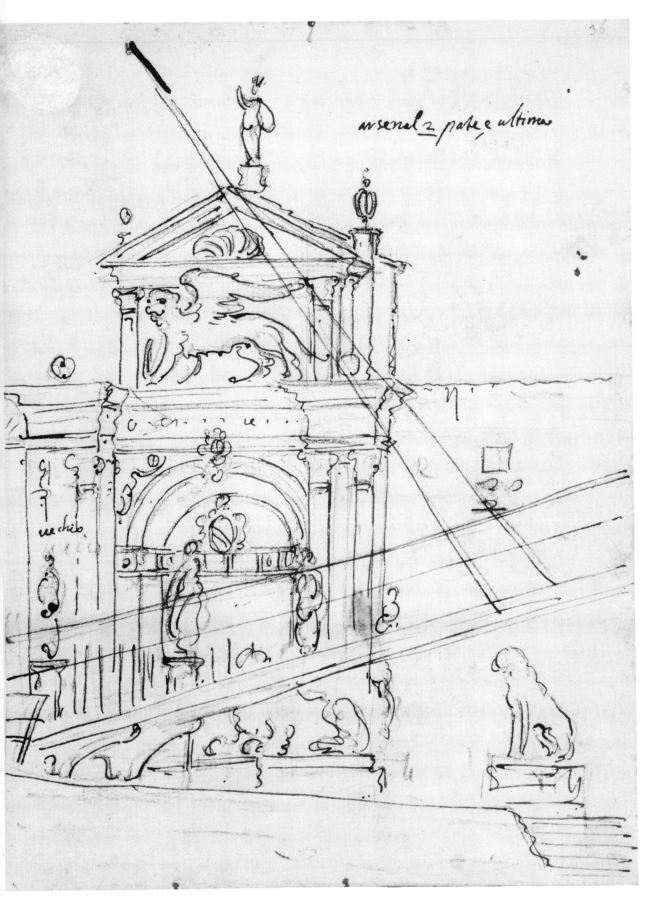

arsenal 2 parte e ultima

vechio

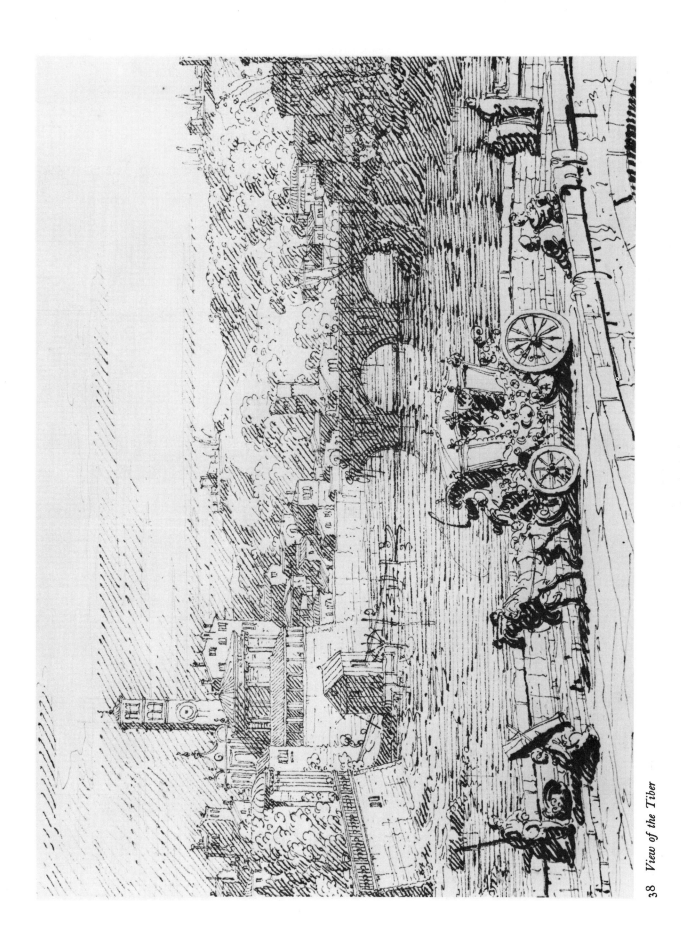

38 *View of the Tiber*

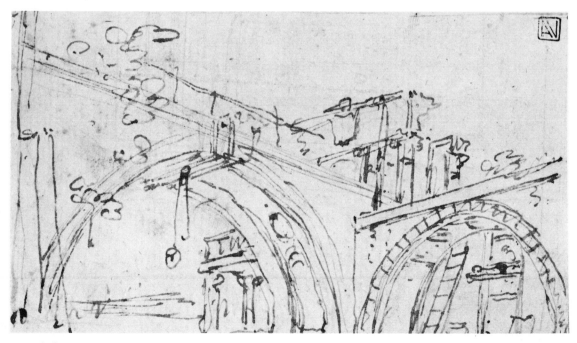

39 *View of Rome*

40 *Arches*

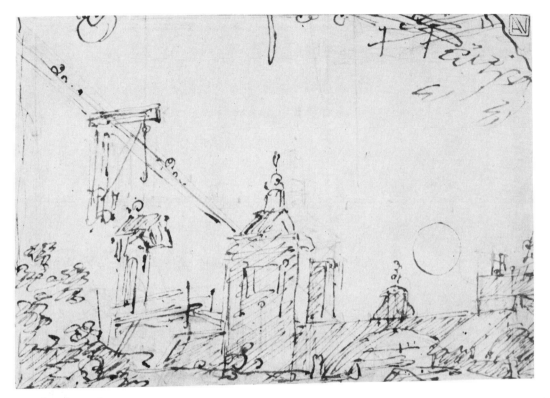

41 *Imaginary view*

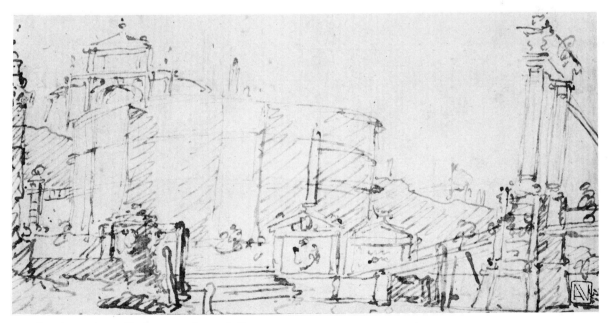

42 *Imaginary view with the approach to a bridge*

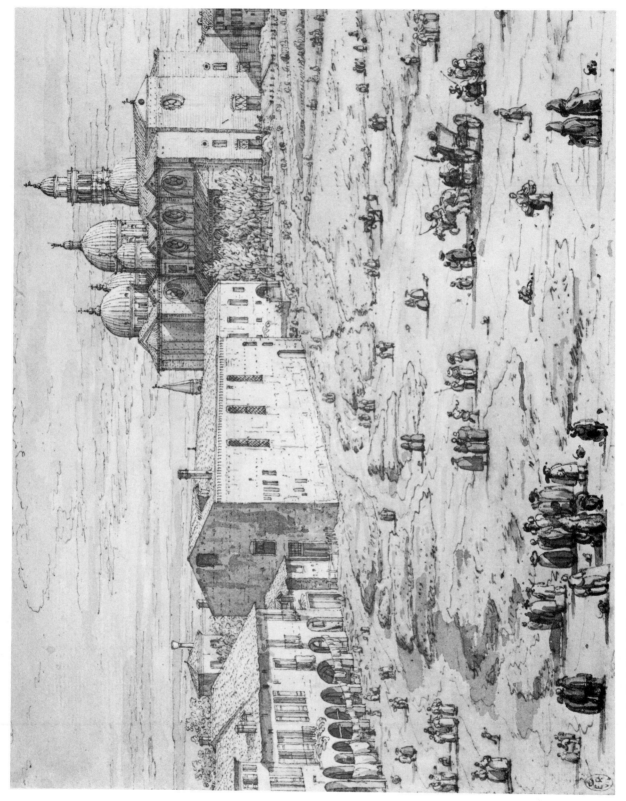

43 *S. Giustina in Pra' della Valle at Padua (detail)*

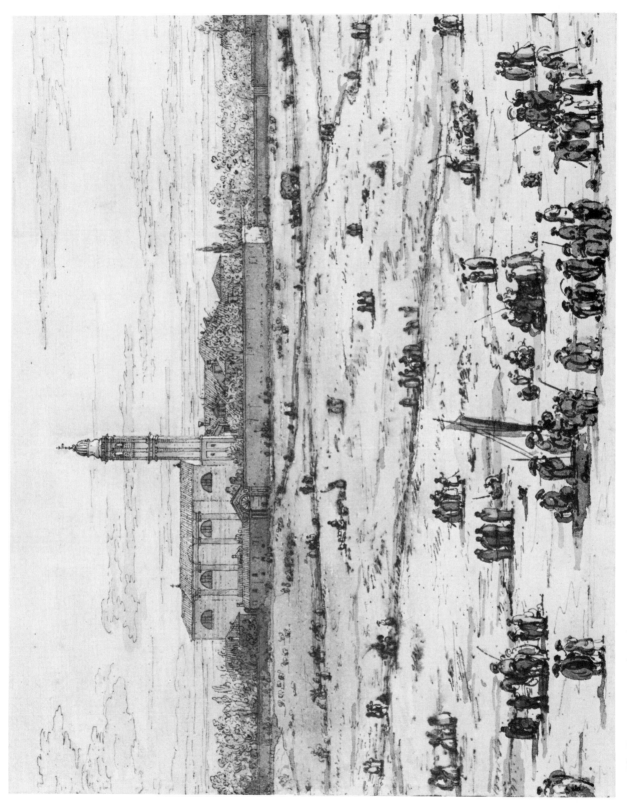

44 *The Pra' della Valle (detail)*

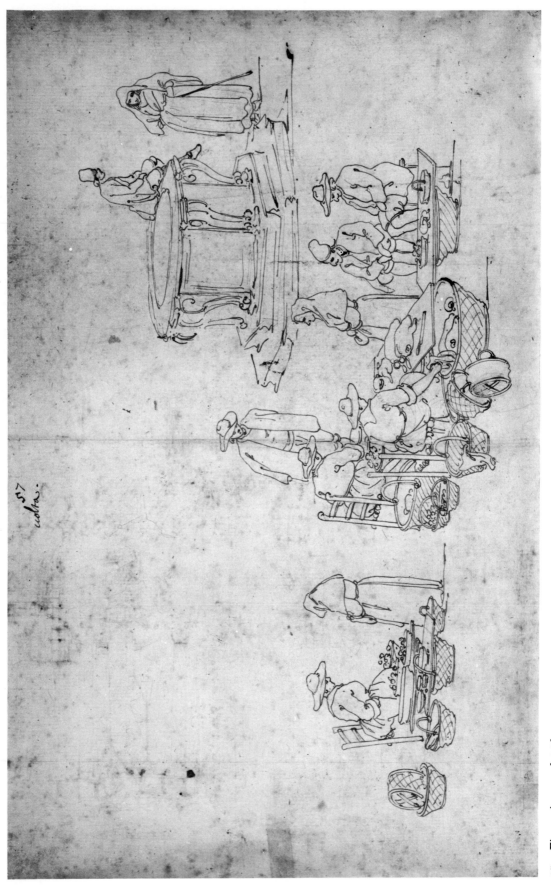

45 *Figures in a market-place*

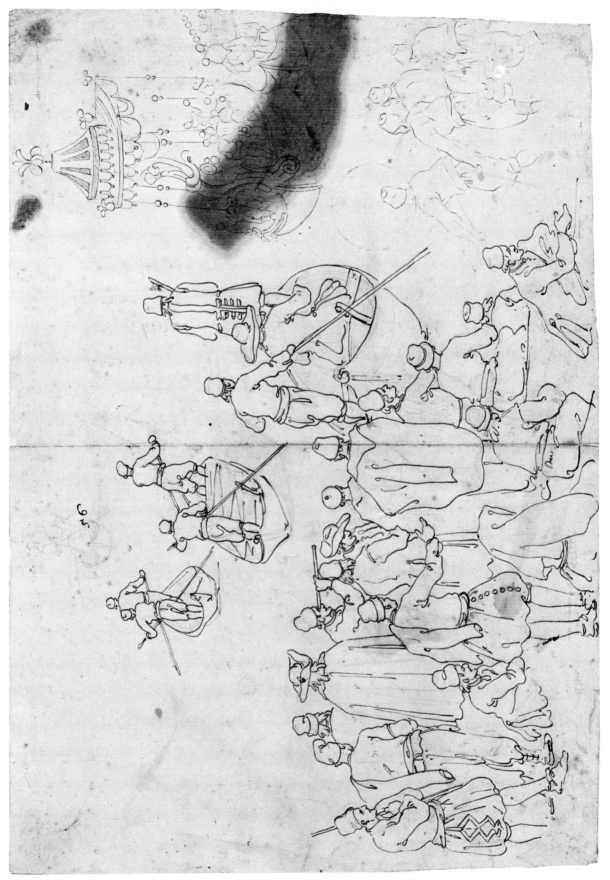

Rowers and other figures

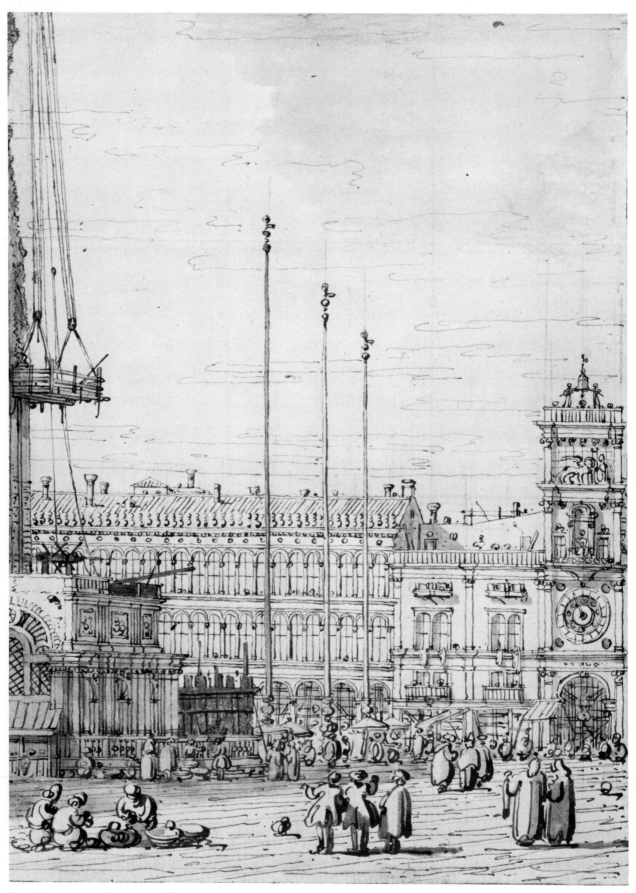

47 *The Piazzetta, with the Campanile of St. Mark's*

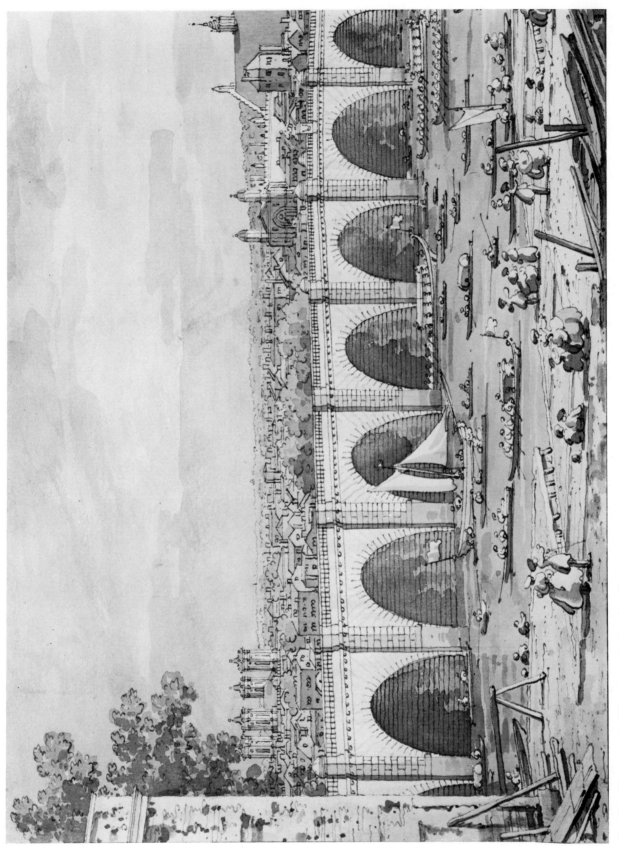

48 *The Thames, with Westminster Bridge (detail)*

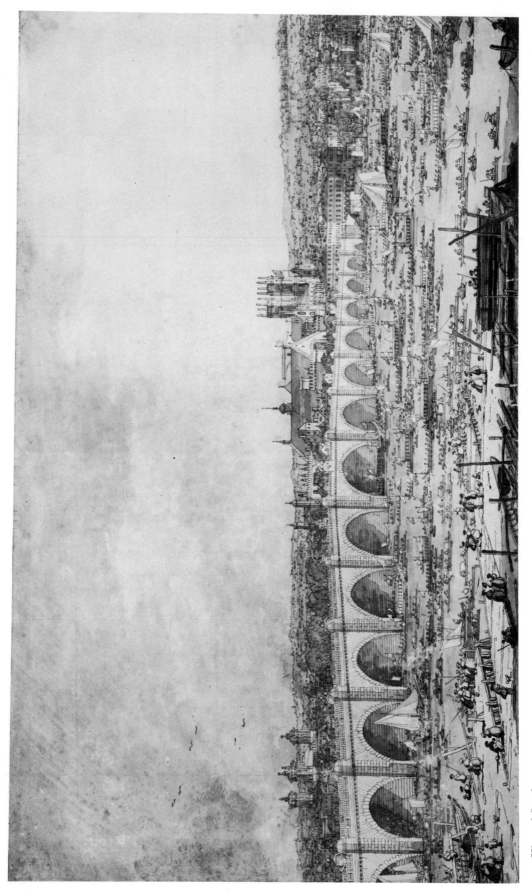

49 *View of London*

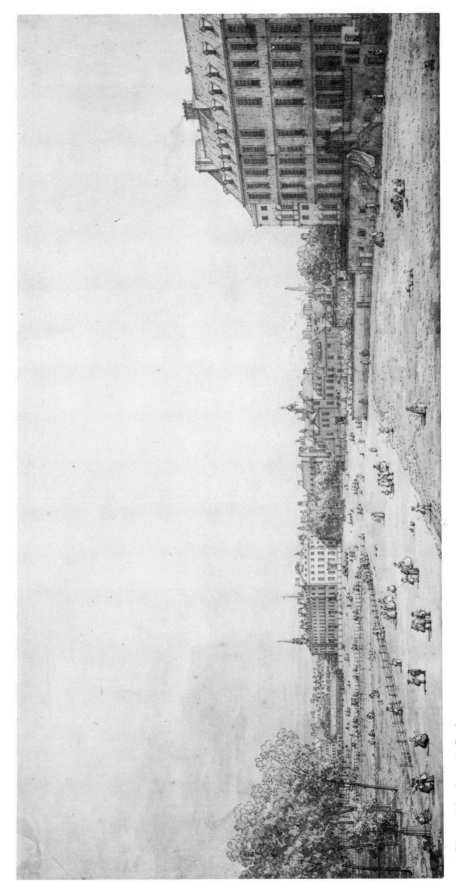

50 *View of St. James's Park*

51 *Little Walsingham House, London*

52 *The old Horse Guards and the Banqueting Hall*

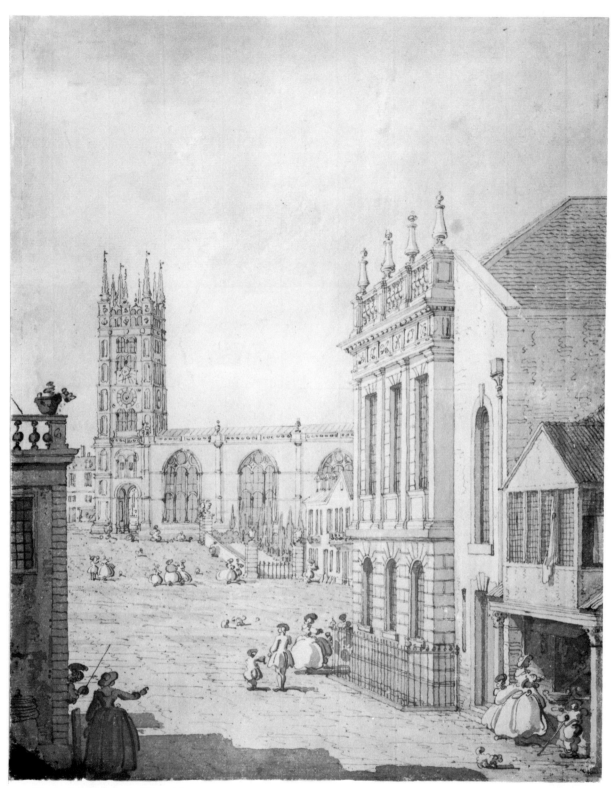

53 *View of the square at Warwick*

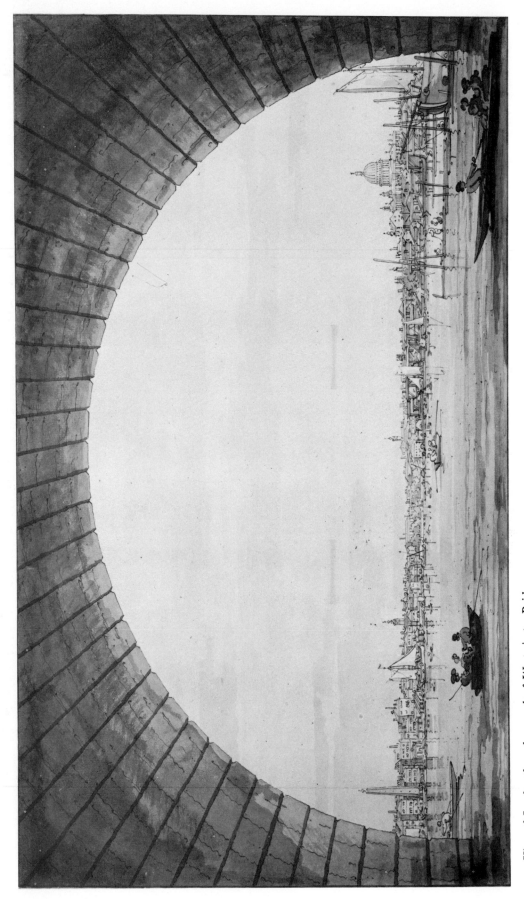

54 *View of London through an arch of Westminster Bridge*

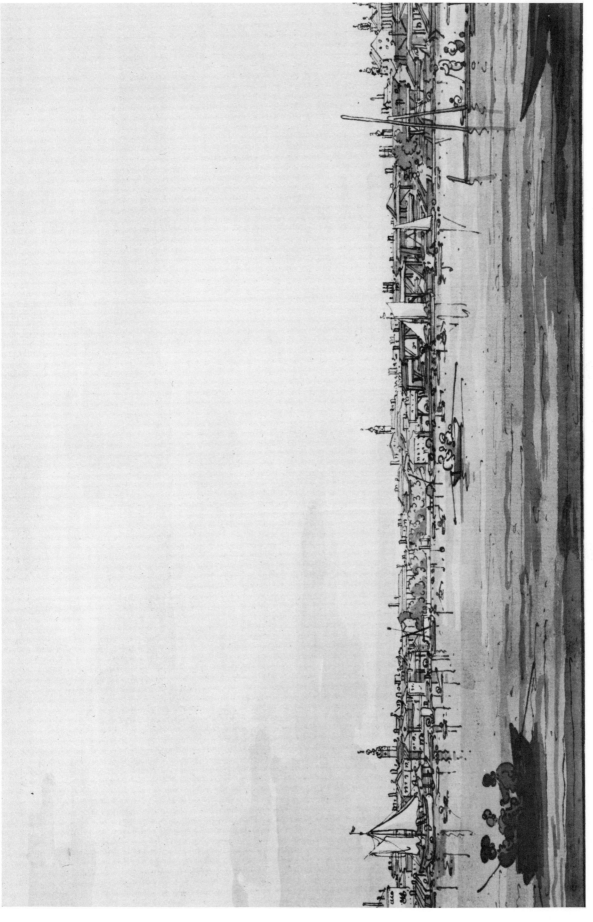

55 *(Detail of No. 54)*

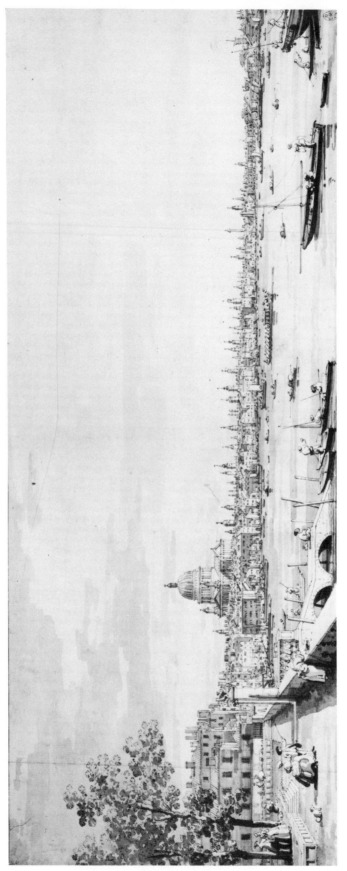

56 *The Thames from Somerset House*

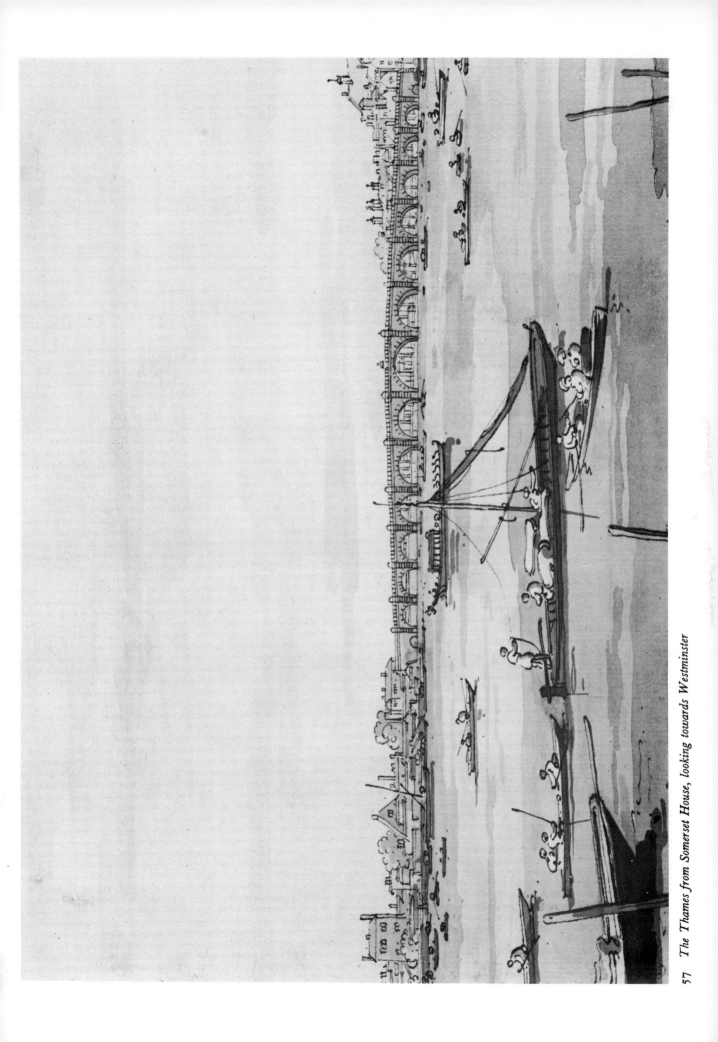

57 *The Thames from Somerset House, looking towards Westminster*

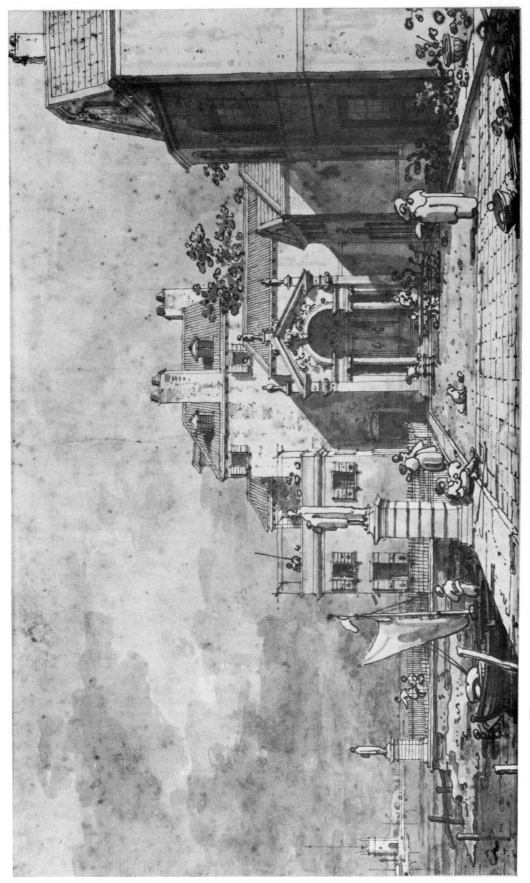

58 *Capriccio, with Montagu House*

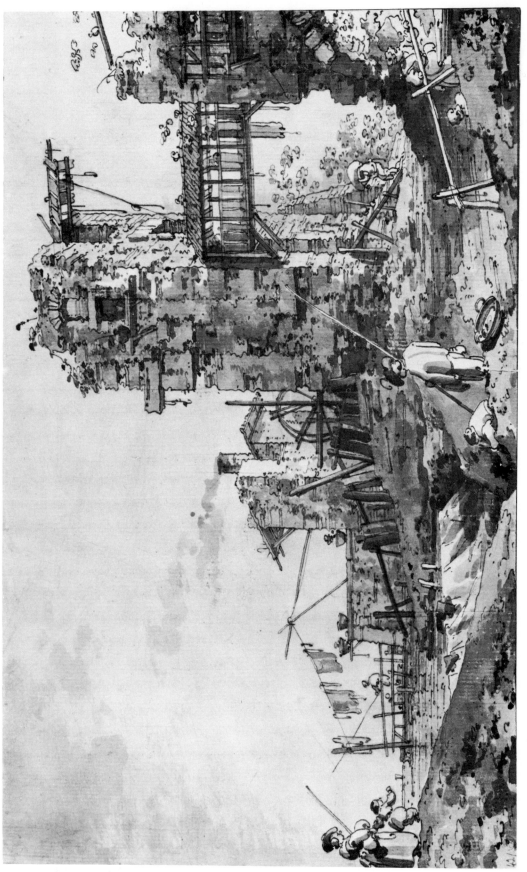

59 *Capriccio, with a mill*

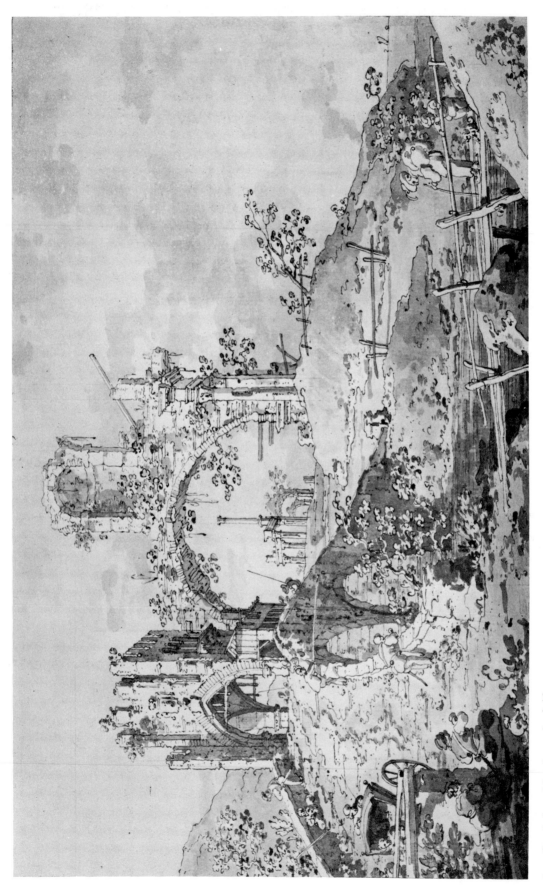

60 *Capriccio, with ruins and a bridge*

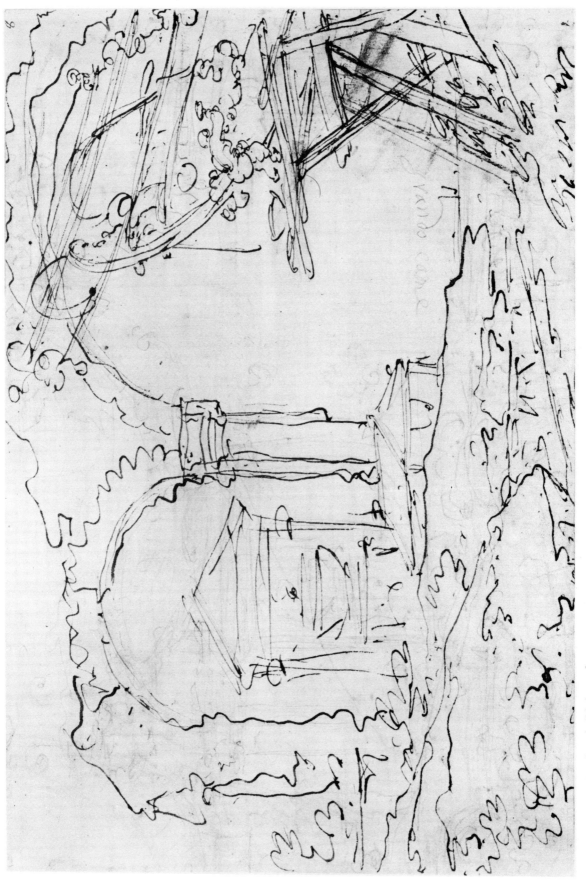

61 *Capriccio, with a boat-builder's yard*

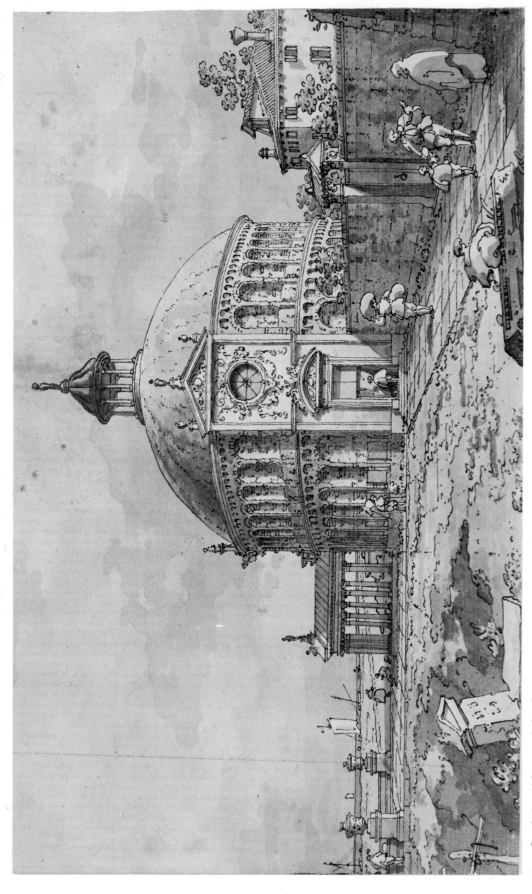

62 *Capriccio, with a round church*

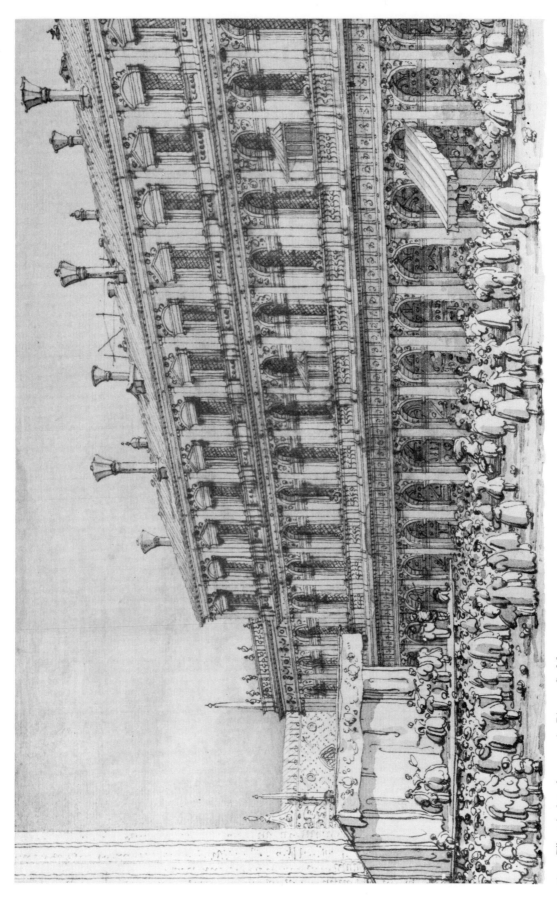

63 *Theatrical performance in Piazza S. Marco*

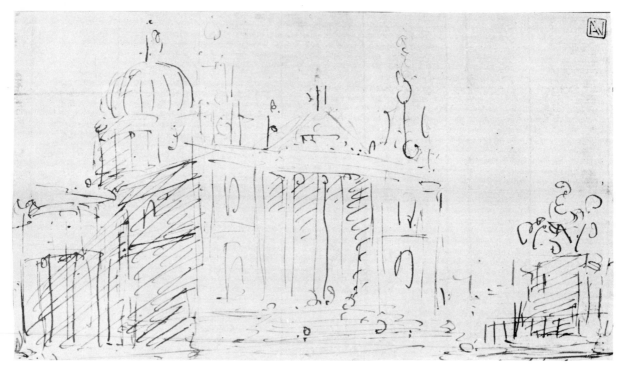

64 *The Giudecca canal*

65 *A church and a square with a statue*

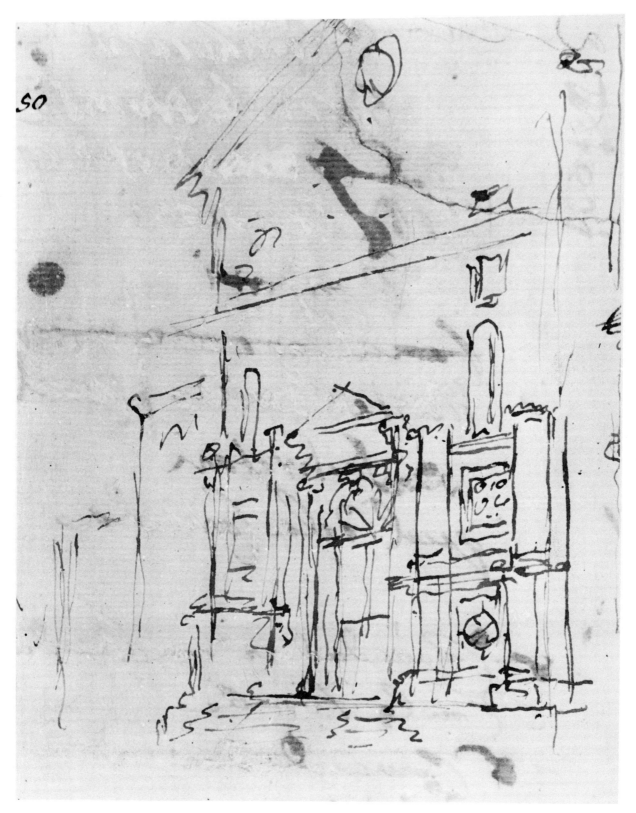

66　*Façade of the church of La Pietà, Venice*

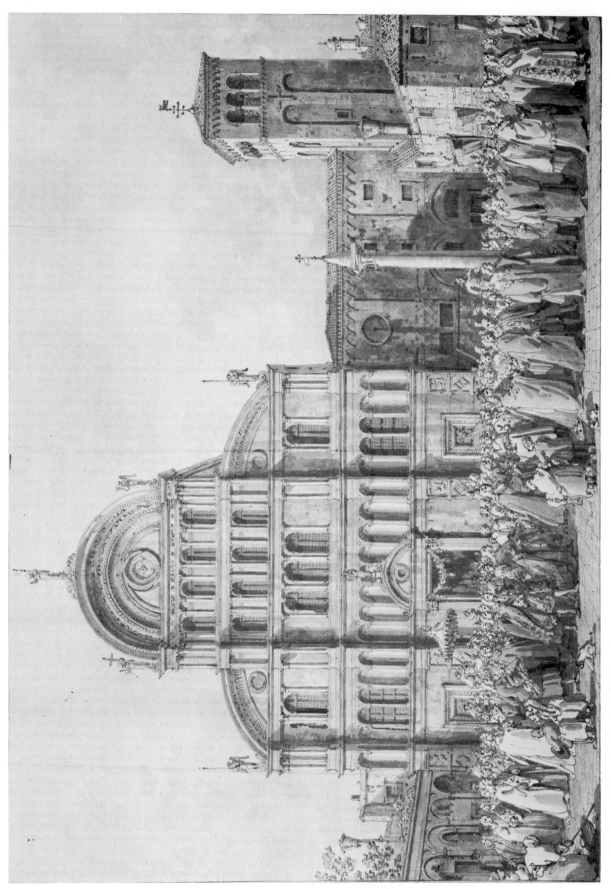

67 *The Doge visiting the church of S. Zaccaria*

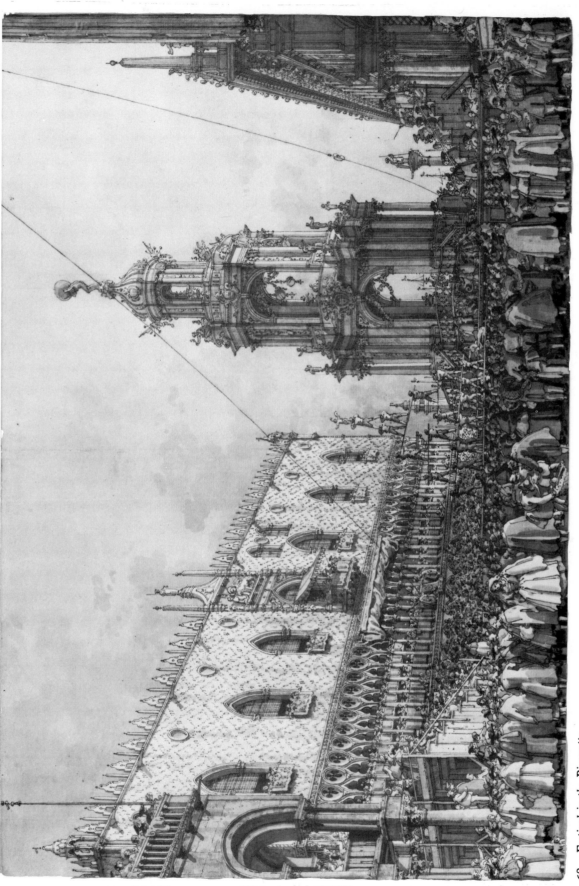

68 *Festival in the Piazzetta*

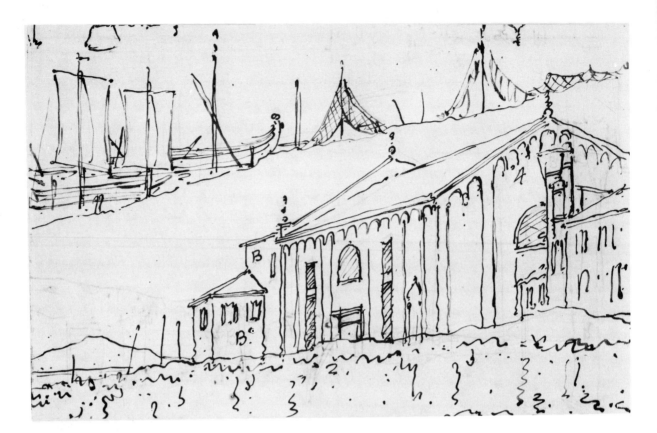

69 *S. Marta, Venice*

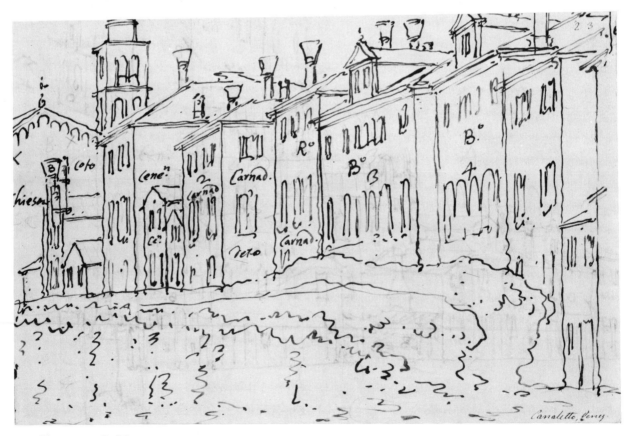

70 *Houses near S. Marta*

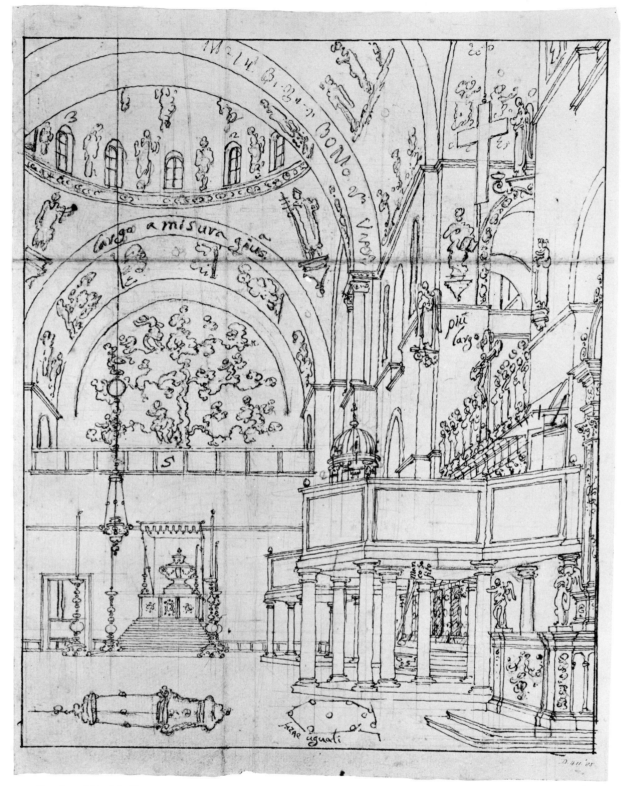

71 *Interior of St. Mark's*

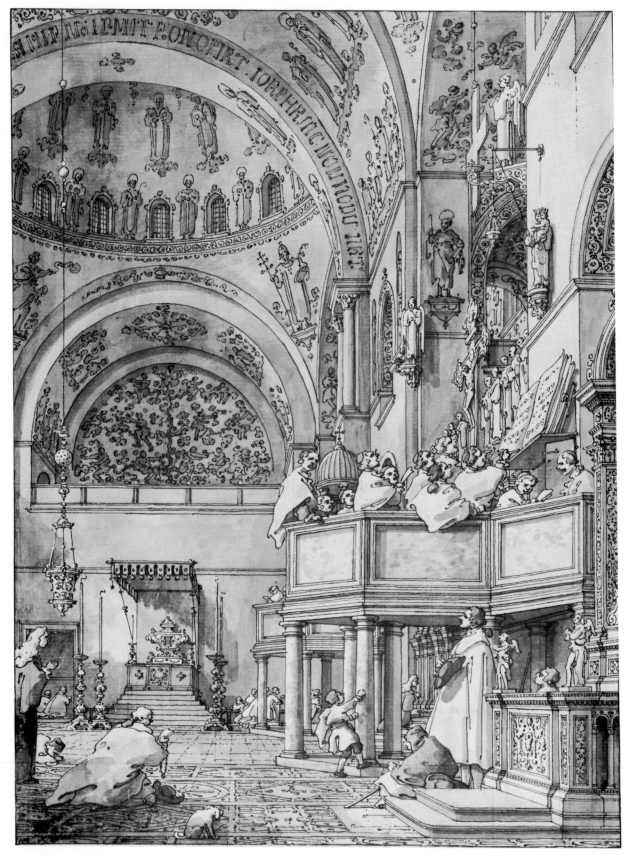

72 *Interior of St. Mark's*